Encyclopedia of Living Artists in America

Second Edition

A visual guide to
artists living in America,
complete with their names and
addresses, as well as biographies,
personal comments and sample works.

DIRECTORS GUILD
PUBLISHERS

Manuscript Editor: Constance Franklin
Art Director: Henry J. Breuer

Encyclopedia of Living Artists in America

A Visual Guide to Current Art in America

Copyright @ 1987 Directors Guild Publishers

CORERRESPONDENCE regarding material should be
sent to:
Directors Guild Publishers
P.O. Box 369
Renaissance, CA 95962
(916) 692-1355

Library of Congress Catalog No. 87-71592

Main entry under title:
Encyclopedia of Livings Artists
 I. Artists - United States - Biography.
 2. Art, Modern - 20th Century - United States

ISBN 0-940899-01-9

Printed in Hong Kong

Bente	Schofield	Hardy	Pape
Flynn	Verdella	Mott	Tice
Rockefeller	Huntor	Hung	Peru
Wright	Saint James	Schumann	Goss

On the Cover......

See artists biography and reproduction in the
color section on pages 9 - 34

We encourage you to contact directly any of the
artists listed in this publication.

Encyclopedia
of Living Artists
in America

CONTENTS

Art is long, life is short, decision difficult and opportunity fleeting. To act is easy, to think is hard, to act as we think irksome. Beginnings are always gay; the threshold is the place of hope. The boy wonders, and this first wonder forms him; he learns in play, to find it earnest. We are born imitators, but who knows what we should imitate? Seldom is excellence found, still more seldom valued. The peaks attract us, not the mountain-paths; we gaze at the summits and loiter in the plain. Only a fraction of Art can be taught; the artist needs the whole. He who knows but half is always wrong and talks much; he who has the whole works, and talks little or late. The talkers have no secrets and no power; their teaching, like a new loaf, tastes good and satisfies us for a day; but flour cannot be sown and seed-corn should not be ground. Words are good, but they are not the best. The best cannot be told in words. The spirit behind the act is the highest. Only spirit can comprehend action and recreate it. No one understands what he does when he acts rightly, but we always know when we are wrong. He who works with signs only is either a pedant, a humbug, or a fumbler. There are plenty of such and they are happy together. Their chattering holds the scholar back, and the best are appalled by their consistent mediocrity. The true artist's teaching opens the mind, for deeds speak where words fail. The true scholar learns to pass from the known to the unknown and draws nearer to the master.

Wilhelm Meister's Apprenticeship
Goethe

M.D. Abramowitz

401 East 80 St. Gracie News, New York, NY 10021
(212) 570-6629

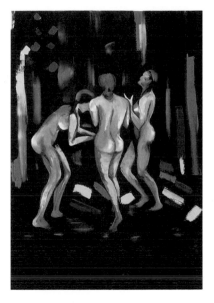

1985 - Illustrator and author of the Rarebit Fantasy, a children's book of historical overtures. 1986 - Created a series of 12 sexual interpretations of the Zodiac, 48" x 60" oils. An erotic journey of mind and emotions through color elevated within a level beyond thinking 1986 - Michael Katz Gallery, Houston St., NY, Jacqualines, East 61st, NY; Grumbacher Award for watercolors. 1987 - Art Expo NY Jacob Javitz Center. April Bathers owned by David J. Rowland, Stockton Holdings Ltd., London, New York.

April Bathers. Oil, 48 x60. Private collection.

Fiore Ai

530A 7th Street Road, New Kensington, PA 15068

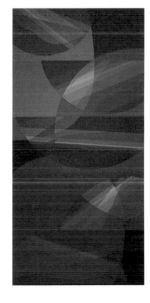

Works in private and public collections. Education includes MFA Washington Univiversity; St. Louis, Missouri, MA & BA. College teaching experience and exhibitions. Artist is concerned with color, light space and movement--cosmic, electronic, microscopic light; inner and cosmic space, with serial imagery, photomosaic transparency and dramatic movement.

Stellar Light. Acrylic, 85 x 42. Artist's collection.

Fernandez M. Albert

1125 Lexington Avenue, New York, NY 10021

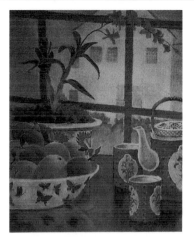

Colombian born; living in the USA since 1964, mostly in New York City. He has been in artist's schools in Connecticut, New York University, Art Students League, Pratt; taking from them the best they could offer according to his needs. He has exhibited throughout the city in galleries like Womanart, Paco, Nena's Choice, Miller, Dos and Matizes, among others.

Still Lite by Window. Oil, 18 x 22. Artist's collection.

Erin Alway

1539 Liholiho St., Apt 204, Honolulu, HI 96822
(808) 536-9056
dba "Always Art", 999 Wilder Ave #504,
Honolulu, HI 96822

Erin Alway focuses her art and passion on portraits
and landscapes of the people and places where
she has lived and travelled. Her works are in
many collections throughout Europe, Canada,
USA and Mexico. Professional artist, muralist,
designer and instructor.

International Marketplace 1981. Oil, 30 x 40. Artist's collection.

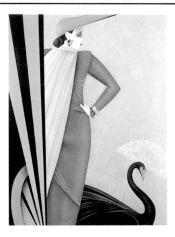

Richard Andri

46 Cherrywood Drive, Manhasset Hills, NY 11040
(516) 358-7986

Theatre Academy (set, costume design)
Prague (Czechoslavakia) 1979. 1980-1983
worked in West German Theatres on over 25
professional productions. Since 1983 lives in the
USA. Work held in private & corporate
collections including those of Roberta Flack,
Boy George and Fine Art Acquisition. Also seen
in magazine and poster editions. Exhibits
periodically nationwide.

Leda. Acrylic, 36 x 48. Private collection.

Francoise A. Armstrong

54 Bartley Hill Rd., Londonderry, NJ 03053
(603) 434-6766

A 20 year veteran of technical art, Francoise
Armstrong grew tired of the stresses of
professional life and returned to her first love,
painting. She also works in pastels on a various
number of subjects.

Blue Macaw. Pastel, 12 x 15. Artist's collection.

Stephen J. Arthurs

195 Markland Street, Suite 2, Hamilton, ONT L8P2K7
Canada (416) 521-1890

Represented by Sande Webster Gallery, 2018
Locust St., Philadelphia, PA 19103 (215) 732-8850

Winner of numerous national and international
awards. These images depict a vision of 4th and
5th dimensions compressed onto 2 dimensions
with historic content. Arthurs' aerial explorations
reside in many public collections including Art
Bank, Ottawa; Queen's Park, Toronto; and art
galleries throughout Canada.

*Ascendant Heron: That which rises from the grave is the
essence of what went into it.*, Acrylic, 10 x 13. Private
collection.

Lois R. Beck

10300 SE Champagne Lane, Portland, OR 97266

A self-taught realist artist confident in oils,
pastels, watercolor or sculpture. Children,
cherubs or ladies, with a romantic theme,
dominate the subject matter. Each piece is a
challenge in detail whether miniature or larger.

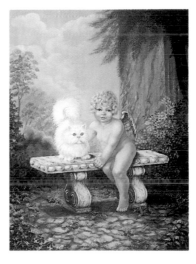

Garden Conversation. Oil, 18 x 24, Artist's collection.

Rami Benatar

150-15 72nd, Apt 6H, Flushing, NY 11367
(718) 575-1967

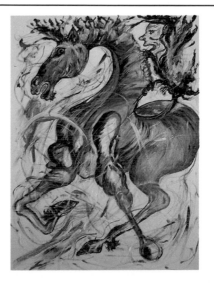

Represented by Serge Lenczner Gallery,
347 West 57th St., NY, NY 10019 (212) 262-5748
At a very early age, Rami Benatar was
recognized as a gifted and outstanding artist of
his generation. Raised on a Kibbutz, Benatar has
strong influences of the Kibbutz environment and
nature. His work represents a new, unique form of
expressionism. Currently on exhibit in major
international collections.

Horse. Acrylic, 60 x 44.

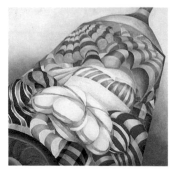

Ibby V. Bente

118-60 Metropolitan Ave, #6B, Kew Gardens,
NY 11415 (718) 441-5389

In my paintings the colours are melted into a
glossy transparency filling the contours of floral
effigies within which a miscellaneous variety of
forms inherent to a composite exotism waver on
border between the animal and vegetal kingdom
rising from the flat surface or I should rather say
evolving volumetrically in deep perspective.

Column. Oil, 24 x 24.

Valeriu Boborelu

45 Kew-Gardens Road, #3H, Kew-Gardens,
NY 11415 (718) 793-6647

I believe that an artist painter has to be able to
feel and think in form-color, to translate all the
events of life in symbol images. Painting is
happiness and joy of life. It is also a social and
cultural manifestation. Above all, I believe that
painting is the inner, telepathic vibration sent to
other souls, the passionate seeking of our real
identity.

Composition #32. . Oil, 80 x 64. Private collection.

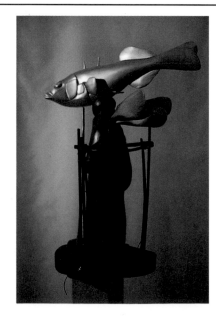

Ralph D. Caparulo

122 Montclair Ave., Montclair, NJ 07042
(201) 783-4736

Figurative sculpture, free-standing and wall-
mounted, in the constructivist style, employs
wood and leather, showing Japanese, Egyptian
or MesoAmerican influence. One of a kind
sculptured furniture by commission only. Other
media: colored pencil drawings, collage and
assemblages. Available for commission work.
MFA University of Penn., BFA Univ. Hartford Art
School.

Urashima Taro. Basswood, 21 x 14 x 8. Artist's collection.

Lisa Collado

920 Park Avenue Apt #2A, New York, NY 10021
(212) 472-2934

Represented by Window Box Gallery, 55 Spring
St., NY, NY 10012 (212) 925-4507

Collections: Egyptian Tourist office, NY; Rutgers
University, New Brunswick, NJ; C.W. Post College,
Greenvale, New York; Museum of Art, Athens
Georgia Exhibitions: Women Artist's series,
Rutgers University; Saint Peter's Church, New York.
Education; self-taught.

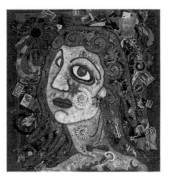

Maat. Collage, 22 x 20. Artist's Collection.

Betty Decter

5412 W. Washington Blvd., LA, CA 90016
(213) 933-8858

"And he said: Not in your life time, sweetie.
Where is the old talent award from the Los
Angeles County Museum of Art? New talent is
new talent whether the artist is young or old! Why
is the word emerging always linked with young as
if they were one word? Why this arbitrary age
limit? Does the talent shrink with age or does it
grow?...."

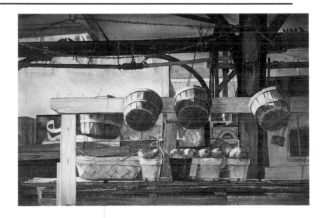

*And then I said to Maurice Tuchman: When you coming for a
studio visit, Honey?* Mixed, 96 x 96 x 96. Artist's collection.

Patry Denton

2948 Pierson Way, Lakewood, CO 80215
(303) 237-4954

The keen challenge of competition, the desire to
create and the notion that I must share my God-
given talents, encourages me to keep the
discipline necessary to become a recognized
artist. I enjoy life and prefer painting realistic,
enjoyable, uplifting subjects in watercolor,
acrylic, pastels and mixed media.

Potatoes Have Eyes. Watercolor, 40 x 30.

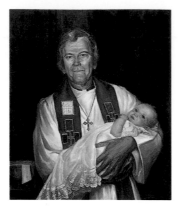

Birdell Eliason

12 North Owen Street, Mt. Prospect, IL 60056
(312) 259-6166

Born Molalla, Oregon. Featured in various publications and news items. Recipient of numerous awards. Paintings in schools, private collections, museums, hospitals, churches, throughout the US. The Baptism was drawn while pastor Zeile dedicated the child to God. Later it was executed into a finished picture. She paints from life.

Sacrament of Holy Baptism. Oil, 24 x 30. Artist's collection.

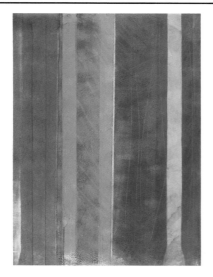

Karen Erla

Old Orchard Street, North White Plains, NY 10604
(914) 946-1271

Represented by Fay Gold Gallery, Georgia; Van Straaten Gallery, Chicago and Texanne Ivy Gallery, Florida
Museum collections: Baltimore Museum; Brooklyn Museum; Huntsville Museum, Alabama; Tampa Museum; Los Angeles County Museum of Art; Metropolitan Museum of Art, NYC; National Museum of American Art; New Orleans Museum of Art; Philadelphia Museum of Art. Solos: Bertha Hurdang Gallery, NY; Elstark, NYC; Manhattanville College, NY.

Untitled. Oil/mixed media, 22 x 30. Artist's collection.

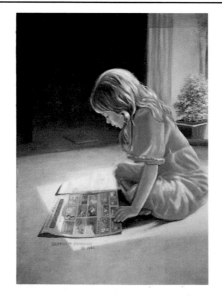

Genevieve Fancher

407 Skyline, Harrison, AR 72601 (501) 741-6345

Represented by The Gallery, 121 West Ridge, Harrison, AR 71601 (501) 741-6669

Fancher likes to touch the spirit of her models I in her portraits; using pastels or oil she brings life into portraits and excitement into landscapes through intense study of the subjects. She has taken workshops and courses under art Instructior John Howard, San Den's Portrait Institute, Foster Caddell and Albert Handell. Printed on magazines, calendars.

Sunday Funnies. Oil, 16 x 20. Artist's collection. Prints available.

Carolyn Sheila Ferris

10 De Montfort Avenue, San Francisco, CA 94112
(415) 334-1646

Represented by James Youtz, 337 Eastgate Lane,
Martinez, CA 94553 (415) 228-4016

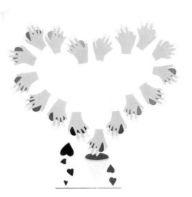

Born in Denver, Co. Studied at Denver University/
Colorado Women's College, Littleton, Colorado;
San Francisco State University, and Academy of
Art College, San Francisco, CA. Carolyn now
uses acrylic and pencil as her mediums - both
are used in some works. She is a self employed
illustrator, and is currently working on a "cloud"
series.

A New Love. Acrylic, 12 x 14. Private collection.

Gilbert D. Fletcher

4631 Richardson Avenue, Bronx, NY 10470

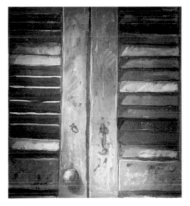

Fletcher centers his paintings on Esoteric
Americana, creating the environments of
everyday life. Introspective colors and energetic
brush strokes shape the strength of his painting
style . Some shows: American Painters in Paris;
Brooklyn Museum '79; Henry Hilks Gallery; Dillard
Univ; Clinton Hill Artists at Pratt; The PBS Collection;
Chi-wara Gallery; Work of Art Gallery.

New Orleans Door. Oil, 28 x 32. Private collection.

Brian Flynn

P.O. Box 369, Renaissance, CA 95962
(916) 692-1355

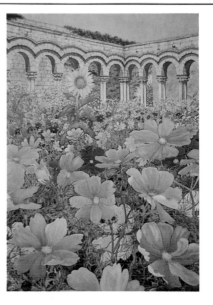

Painting is about the experience of the artist; his
particular vision of the world about him, faithfully
reproduced in colour and light. How could it be
otherwise? Discovering the cloister of San
Giovanni degli Gremiti in its humble medieval
splendour and the erruption of joy and
effervescent colour in the lush vegetation there ,
for me was a perfect balance, a harmony of
man and nature. From nature sprang forth art,
and art, in it's time, serves to enhance nature.

Cloistro da San Giovanni degli Gremifi, *Palermo..* Watercolor,
24 x 36. Artist's collection.

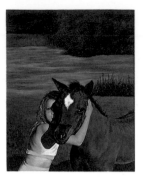

Blanche Gassaway

5041 Ryan Drive, Oklahoma City, OK 73135
(405) 672-8137

Represented by Pine Tree Gallery, 114 Pine Street, Troy, AL 36081 (205) 566-6578

When I retired in 1977 having one year art at OCW Chickasha I took oil painting from a professional for three years. Since then self taught from books. Have shown for Century Center Artisan Gallery; Oklahoma City at Nat'l Cowboy Rodeo. Slide juried shows at Salmagundi Club in NY, Gregg Art Gallery, La Puente CA. I try with realistic style to convey the feeling of being there.
First Love. Oil, 16 x 20.

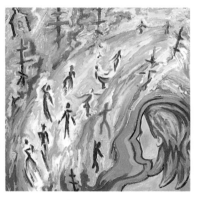

Ludmila Gayvoronsky

1690 Union Street, Apt 2C, Brooklyn, NY 11213
(718) 756-3453

Represented by Emergent Collector, 62 Second Avenue, NY, NY 10003 (212) 254-4060

Ludmila Gayvoronsky's style could be described as loose, cold, free and sensitive. Having been a realist painter for years, she directed her attention away from the concrete image of landscape toward the external qualities. Often she lets her subconscious dominate her paintings without knowing what it means until long after it is finished.
My dear friends very slowly gone away. Oil, 26 x 26. Artist's collection.

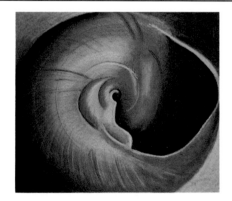

Jane Goss

P.O. Box 107, Kensington, MD 20895 (301) 949-7740

Represented by The Loft Gallery, 313 Mill St, Occoquan, VA 22125 (703) 490-1117

Influenced by a concern for the protection of the earth, Ms. Goss works with a variety of drawing materials to create simple, often large-scale images of the natural world. She also works with pastel and acrylic on linen, still life, figures, and experimental polaroids. She holds a BFA from the MD Institute. She has been in many shows and won many awards.

Memories of Georgia. Mixed drawing, 25 x 26. Artist's collection.

Jackie Greber

21554 Mountsfield Drive, Golden, CO 80401
(303) 526-9518
Represented by Inkfish Gallery, 1810 Market St.,
Denver, CO 80202 (303) 297-0122

Sculpture evolving from constructivist and
minimalist traditions, exploring transparency,
color, real and illusory space. Solo exhibits
Molly Barnes, Los Angeles; La Jolla Museum
Contemporary Art; MacHouston, Pasadena, CA;
Inkfish, Denver. Over 50 group exhibits
nationally include LA County Museum of Art; Ariel,
NY; Newport Harbor Art Museum,
San Francisco, New Mexico, Arizona.

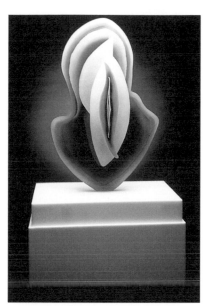

Full Bloom. Sculpture, 32 x 17 x 16. Artist's collection.

Jonathan Green

Route 1 Box 112, Yemassee, SC 29945
(803) 846-8522

Represented by Richard D. Woodman, 3941
Doral, Rapid City, SD 57702 (605) 342-3894

Born in Garden Corner, SC; BFA, The Art Institute of
Chicago, '82; Museum Collections: Evans-Tibbs
Collection, Washington DC; King-Tisdell
Collection, Savannah, GA. Exhibitions: Atlanta
Life '87; U of Chicago '86; Atlanta U Center '86; U of
Illinois '86; Vaughn Cultural Center, St. Louis, '86;
Chicago Cultural Center, '85; State of Ilinois Art
Gallery '85.

Gullah Series #1. Oil, 36 x 48. Private collection.

Mary L. Harbert

739 1/2 Pershing, San Bernardino, CA 92410

My canvas...a place for color and light to rest,
my thoughts, mood, feelings at that time. . not to
be lost or scrambled like so many words
unheard or unspoken...to communicate with
another human being who has taken the time to
see....art through me!

The Importance in Darkness. Oil, 24 x 36.

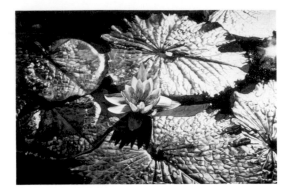

Fran Hardy

Box 389 RD #1, Claysville-Burnsville Rd., Claysville, PA 15323 (412) 663-4772

My work draws inspiration from the natural world. I especially love the vibrant colors, forms and light of the tropics, but also the plants, animals and trees of the temperate climate. I delight in the seclusion and introspection of creating my own world through my art.

Waterlily-Sunlight. Watercolor, 29 x 41. Artist's collection.

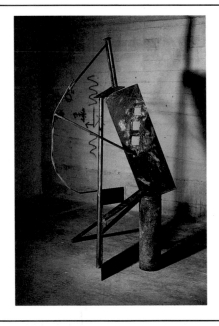

Hunter Ken Herman

837 Traction Avenue, Suite 102, Los Angeles, CA 90013 (213) 617-9300

Herman works as a painter and sculptor depicting subconscious perspectives from a spiritual language of mystical symbols reaching inward without losing touch with humanity. Sculpture surfaces are worked by hammering, brazing, and powder-coatings that lead one to look into and beyond what is immediately there.

Salvation. Mild steel, 80 x 53 x 56. Artist's collection.

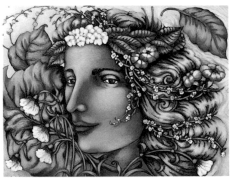

Carter Holman

Represented by Art Discovery, PO Box 183, Oregon House, CA 95962 (916) 692-1422

Carter Holman is a self taught genre artist. She chooses to depict life at home, life in rural America. Ms. Holman's paiintings tell their own specific story. They chronicle a world where nothing intrudes to mar a peaceful afternoon. Ms. Holman is a native of Oklahoma and resides presently in Arizona. Her works enjoy wide representation through the west and southwest.

Nuevo Spring. Oil, 30 x 40. Private collection.

George Horvath

P.O. Box #5, Site 24, RR #12, Calgary, Alta.
Canada T3E 6W3 (403) 246-3061

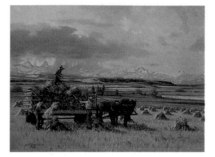

A talented and hard working individual, George quickly established himself in Canada after immigrating to Calgary, Alberta in 1956. George believes that confidence is the key to establishing visual and technical personalism. It takes years of hard and honest work to develop a uniquely personal style. There is so much that influences one's early days of efforts. I believe true art is one's personal interpretation of nature within the framework of realism.

Loading for Threshing Oil, 20 x 26. Artist's collection.

Shih-Chieh Hung, APSC.

4004 Mozart Dr., El Sobrante, Richmond, CA 94803

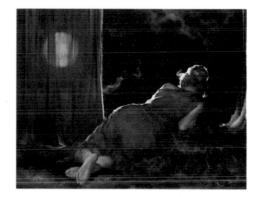

Mr. Hung, born in China, has spent 40 years as an artist. He and his family immigrated to the US in 1980. His very best subject matter are human lifeforms and portraits. He has painted noted portraits of President and Mrs. Reagan and Attorney General Edwin Meese. Facts about Mr. Hung appear in the "Directory of American Portrait Artists".

Moonlight. Oil, 38 x 48. Artist's collection.

Ginny Hunter

3920 Crawford Ave., Coconut Grove, FL 33133

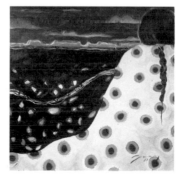

Ginny Hunter's work reflects a continuing interest in the natives of the southwest, with western landscapes as a backdrop. She enjoys working in a representationalistic style, focusing on pastels and oils as her vehicle of expression. Together these things produce a strong presence in her figures. Ginny has participated in shows in Miami, Denver, California, and Columbia.

The Distance. Oil, 48 x 48. Private collection.

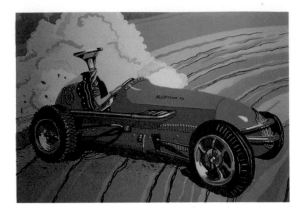

Annette M. Izac

2615 South 8th Street, Arlington, VA 22204

Art is my livelihood and much more. Many times it has been my friend when I was lonely and my solace and strength when I was sad and all else seemed to have failed. In my memory there has never been a time when I did not paint and draw. The more I learn of art the more I find I do not know. It has become an all-consuming fascination. Art is my life.

Screw Driver. Gouache, 13 x 11. Artist's collection.

John Lester Jordan

418 E. Hamilton St., Allentown, PA 18103

Represented by Gallery Enterprises, 310 Bethlehem Plaza Mall, Bethlehem, PA 18018

Artist's awards include one national level. He has shown in USA, Hawaii, Australia and is also a Goldsmith and works in other media. This work began in 1984 in Hawaii and is still growing to salute Dali's proclivity toward magnanimity, and due to a few faithful pedants encountered early on in Texas...but everyone should be stood in a line and made to study Dali.

Homage to Dali with Fried Eggs. Mixed, 28 x 43 x 14. Artist's collection.

Mi Seon Kang

61 East 97th St., #17, NY, NY 10029

I get spiritually high on art. That must mean perhaps I can reach higher spiritual understanding by doing art and searching for deeper spiritual understanding. This is the source and nourishment for artistic creativity.

Levitation. Mixed media, 20 x 23 x 26. Artist's collection.

Marjorie B. Kaye

7 Candlewood Road, Lynnfield, MA 01940
(617) 334-5122

Represented by Ariel Gallery, 76 Greene St., NY,
NY 10012 (212) 226-8176

I received my BFA from Syracuse University in 1979
and have been steadily concentrating on my
work since. The content of the work
concerns itself with balance, creating a system of
motion through contrast, color, light and
pattern as it appears in nature. Influences of
music and horticulture reflect the geometric and
organic forms present in my work.

Beacon Quadrangle. Drawing, 14 x 19. Artist's collection.

Laszlo Kohanecz

100 NE 161 Street, North Miami Beach, FL 33162
(305) 949-3910

Represented by Lake Placid Gallery, 5 Main St.,
Lake Placid, NY 12946 (518) 523-2330

Born in Temerin, Yugoslavia. Studied under A.A.
Gentilini in Paris: 1963-69. Work in permanent
collection of Lowe Art Museum (Miami). Work
was on display in the chambers of Committee on
House Adm., House of Rep., Washington, DC
(1973) and in Museum of Science (Miami, 1980).
Select member of National Museum & Gallery
Registration Association.

The Sad Clown. Oil, 16 x 20. Artist's collection.

J.V. Kopp

6935 Arrowwood Ct, Modesto, CA 95355
(209) 869-3745

Represented by Leon Boyar, PO Box 1511 Wall St.
Station, NY, NY 10268 (209) 869-3745

Born in San Francisco. Graduate of Lone
Mountain College. Art award of excellence in oil
painting given by National League of American
Penwomen 1980. Works in numerous private
collections. Maintains studio in Modesto. Works
exclusively in oils. Representational paintings.

The Sojourner. Oil, 20 x 24. Artist's collection.

Malcolm Lane

25995 East Lane, Covelo, CA 95428
(707) 983-6708

Represented by Lane Enterprises, 25995 East Lane, Covelo, CA 95428 (707) 983-6708

A prize winning high school artist, graduating 1969. First in Fine Arts From St. Benedict's College, Atchison, Kansas. Internationally known for designs, posters and magazine covers. Is presently commissioned to map Round Valley, California."Gold and sunshine are synonymous with the California mystique."

California Gold. Gold & oil, 5 1/2' x 9'. Private collection.

Art Langdon

5D-Kleine, 211 Duke Ellington Blvd, NY, NY 10025

Represented by AOAV Aristensen, Box 21, Site 27, Val-Caron, Ontario CANADA P0M 3A0

Langdon creates a unique style: two paintings is only one Langdon painting! There are two landscapes in one Langdon painting. The first painting is in one vertical position, and the second landscape is the other vertical position. Langdon has many international and national exhibits in Canada and the US. Working artist in oils, acrylic, serigraphs and limited editions.

Langdon Green Reflections. Acrylic, 36 x 36. Artist's collection.

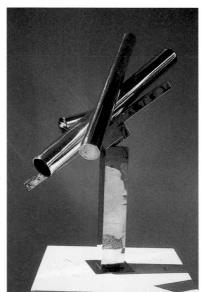

Christiane Lazard

28 Gough Street, San Francisco, CA 94103

Represented by A Tiburon Affair, 82 Main Street, Tiburon, CA 94920

Sculptor born in New York, studied and worked in France from 1948 to 1982. Has shown in group shows in France and Belgium and has had two individual shows, one in Paris and one at the Palace of the Legion of Honor in San Francisco. Her works are also in private collections throughout France and the US. She now lives and works in San Francisco.

Star Gazer I. Brass, 29 x 20 x 22.

Jessica Lenard

252 W. # 30th St., Ny, NY 10001

Represented by Roberto Gautier,
183 Thompson St., New York, New York 10012
(212) 228-8133

I paint as a writer retells his story - at once intimate
and universal. In my images I try to convey the
pain, poignancy, and ironies which permeate my
life, everyone's life. Limited edition $250.

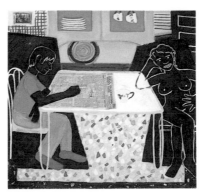

Morning. Mixed media, 58 x 60. Artists collection .

Peter Lynch

9014 Fourth Avenue, Brooklyn, NY 11209
(718) 748-1498

Represented by Wiesner Gallery, 8812 Third
Avenue, Brooklyn, NY 11209 (718) 748-1324

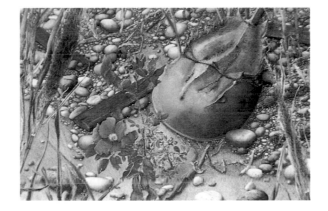

Exhibits regularly in NYC. Has exhibited in CT, MA,
PA, SC, IL, OH, KA, AZ and CA. Represented in
Illinois . by IO Talents Gallery in Zion. Work is in
corporate and private collections. Peter has
received numerous awards for his precisely
micro-detailed intimate nature paintings. He
works in all media and prefers transparent
watercolor and gouache.

Beach Rose. Gouache, 20 1/2 x 26 1/2. Artist's collection.

Ann E. Mancini

43 High St., #4, Greenfield, MA 01301

Within this series, Ann makes use of several
carefully selected slides from her personal work.
The Artist then rearranges her composition to
create a total new work. Working in pastels, Ann
is able to keep her colors fresh and moving. Yet,
beyond the norm of the rich visuals, Ann
incorporates lines of poetry adding to her
landscapes a narrative sense

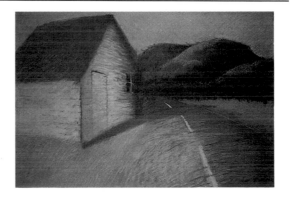

Anotherscape No. 1. Pastel, 28 x 38. Artist's collection.

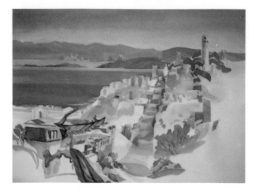

Middleton c.p.e. (Holly)

Studio 9x, 3665 Fillmore St., San Francisco, CA
94123 (415) 931-7549

Represented by Ona Elsner Consultant, 1200
Gough Street, Cathedral Tower, 7A, SF, CA
Graduate in Fine Art, Holly has pledged her artistic
talent to reveal to us the inherent beauty and
integrity that can be found in a person's features
as well as in natures domain. She is equally well
established in both fields, here and abroad. Her
paintings have a strong sense of design and
lightness of touch which makes you want to
come back for yet another joyful look.
California/Coit Tower, San Francisco. Watercolor collage,
22 x 28.

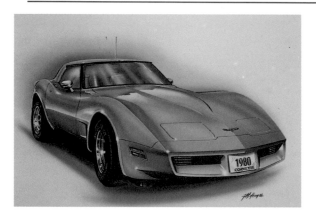

Mr. Jan Midtun

2126 17th Street NE, Rochester, MN 55904
(507) 281-2805

MA Degree in Art. Works in oil, watercolor,
airbrush, ink, pencil. Exhibited at the Currigan
Hall Classic Car Show 85 Denver, CO. I was
interviewed for my artwork by Channel 9 in
Denver primetime news program, Colorado,
May 86. Post Bulletin Newspaper Rochester,
MN. showed my art and story 3/12/87 issue. I
have worked for large corporations, cruises and
airlines in Europe and USA.

Corvette 1980. Airbrush, 20 x 28 3/4. Artist's collection.

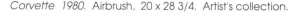

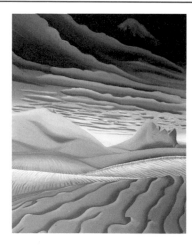

Timothy Wright Moseley

3804 Farmville Drive, Suite #318, , Dallas, TX 75244

Born in Orange, California. Residing in Texas.
Received scholarship from Texas Fine Art
Association, May, 1975. Received BFA Degree
(Honors) in Studio Art, The University of Texas at
Austin. Attended 1978-1980. Also attended
North Texas State University 1975-1978. Exhibited
in various Texas galleries and colleges 1980 -
1987. Currently working on a series of paintings
"Nudes".

Mirage. Oil, 48 x 38. Artist's collection.

Zenaida Talbot Mott

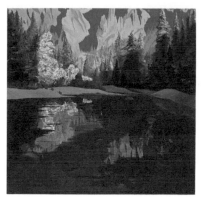

88 Baywood, PO Box 503, Ross, CA 94957
(415) 457-5292

BA, UC Berkeley, Davis; Lived, painted extensively
Africa; Asia; Cambridge, MA; Marin, CA. Elizabeth
Holland McDaniel, Maria Sanchez. MSA; Mac;
guest artists CSPF; Magazine cover paintings;
Exhibited San Francisco, Marin; Yosemite;
Media: oil, acrylic, pen and ink. Currently "Trying
to suggest the real sense of release and magic
found in mountain wilderness."Accepted by
Yosemite National Renaissance Exhibition.

Valley Dawn, Acrylic, 33 x 33. Private collection.

Christiane Pape

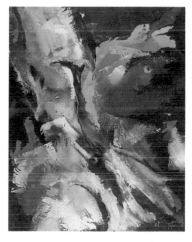

500 East 77th St., New York , New York 10021
(212) 472-9602

Christiane Pape was born and educated in
Switzerland. Painted intensively in Switzerland,
France, Italy and USA. Had shows all over Europe
and America. Her paintings are represented in
major public and private collections in Rome,
Milan, Genoa, Paris, Geneva, London and New
York where she presently lives.

Summertime. Acrylic, 60 x 48.

Estelle Pascoe

1085 Park Avenue, New York, New York 10128

Widely recognized among today's neo-
abstractionists, Estelle's emphasis has been in
acrylic collage paintings and constructions. Her
work has been in numerous one person shows in
Belanthi Gallery in NYC and group shows
throughout the country. She is represented in the
permanent collection of the Art Student's League
of New York and private collections world wide.

Bantam Ballads. Acrylic-collage, 20 x 24.

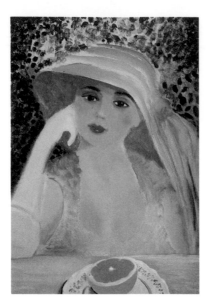

Pera

P.O. Box 500, Oregon House , CA 95962

The more I paint the more my activity becomes mysterious...magical...toching the miraculous. Light, air, colour, water, pigments, a man, a woman, a quiet afternoon, smell of flowers and some birds singing in the background...

La Pamplemousse. Acrylic, 18 x 24. Artist's collection.

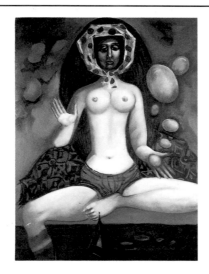

Robert Cleaver Purdy

345 South End Ave., 4G, New York , New York 10280

Represented by Keith Walker Bradley, 310 West 97th St., Suite 21, New York , NY 10025

BA Univ of Indiana. Four Tiffany Fellowships. Beaux Arts Bronze Medal. Four NY One Man Shows. Work shown at Met Museum, Speed Museum, Chicago Art Institute, Penn Acad. Fine Arts, John Herron Inst. & Bklyn Museum. Taught at Eliot Ohara School & U of Louisville. Designed Fashion Pavilion, NY World's Fair '64. Bi-centennial Plate Design, Royal Delft.
The Mystic . Oil, 30 x 40.

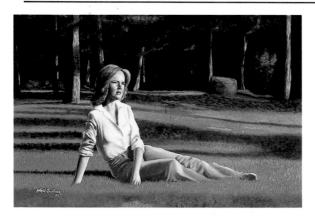

John W. Quillian

3851 Boca Bay, Dallas, TX 75244

Following 3 one-man shows and winning a United Nations show, Quillian turned to artistic reclusion at age 18. In recent years he has sold numerous works and has authored a true crime book scheduled for publication in late 1988. He plans to live between the US and Ireland as both a writer and fine artists. His painting styles range between impressionism and realism.

Jeune Fille Mediter. Oil, 24 x 36. Artist's collection.

Olive Reich

7518 Third Avenue, Brooklyn, NY 11209

Represented by Nahas Gallery, 7618 Third
Avenue, Brooklyn, NY 11209

Painter - instructor - watercolor. Studied Holyoke
College, BA; Art Students League;
 Parsons, NY. Juried Exhibitions, NYC, CA, Penn, NJ,
Neb, Co, Puerto Rico, Alabama.Numerous solo
shows including Brooklyn Botanic Garden '86.
Mem Nat Assn Women Artists, Salmagundi Club,
Artists Equity, Catharine Lorillard Nolfe Art Club, NYC
Many awards including best in WC, Bklyn
Museum.
Country Still Life. Watercolor, 22 1/2 x 30. Artist's collection.

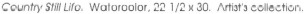

Will Revere

8215 Indiantrail Rd, Brooksville, FL 33573

Represented by Gallery 1, Bay Area Outlet Mall,
15525 US Hwy 19S, Clearwater, FL 33546

Fantasy realist born 1937, NYC. Sudied at Pratt
 Institute and Art Students League in NYC 1970.
Has had numerous showings throughout the
country. Work hangs in private collections in
country as well as Canada. Settled in
Weekiwachi area in Hernando County working
out of own home-studio, doing commissioned
portraits as well as inventory for future shows.

The Garden. Oil, 28 x 60. Private collection.

Heidi Robichaud

Box 111, Hope, AK 99605

Represented by Larry Cohen, Box 654,
Ben Lomand, CA 95005

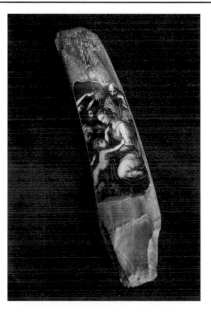

I was born in Connecticut in 1959 and have lived in
Alaska since 1979. I've been involved with
commercial fishing, forestry, and bison ranching
and have been doing scrimshaw since 1981. I
seek to portray the beauty and grace in nature
and in human expression.

Family of St. Francis. Ivory scrimshaw, 10 x 3.

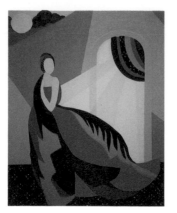

Sally Smith Rockefeller

37 Cambridge Terrace, Cambridge, MA 02140
(617) 492-0155

Currently working on a series of luxuriously patterned, fantastical, acrylic "Portraits" of women. Works combine the decorative and sensuous with semi-abstract "reality". Other subjects: animals, cityscapes, flowers, plants, buildings. Media: acrylic, collage, watercolor, pen and ink. Inquiries welcome; commissions accepted. Seeking agent and/or gallery.

Spanish Lady. Acrylic, 16 x 20. Artist's collection.

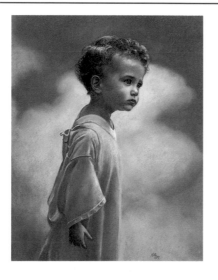

Kitty Scheuer Rodriquez

40 Sterling Ave., Yonkers, NY 10704 (914) 237-3870

Represented by Village Art Gallery, 7 Pondfield Road, Bronxville, NY 10708 (914) 337-7711

My role as a portrait artist is more than simply creating a likeness. I attempt to capture the character and personality of my sitter and thus bring my subject to life. My aim is to work from inspiration rather than desperation. A recipient of many awards, I am a member of several local and national art associations.

Grandpa's Tee Shirt. Pastel, 20 x 24. Artist's collection.

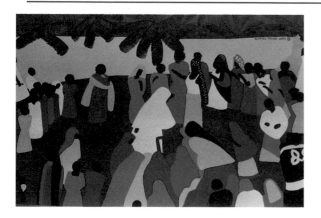

Synthia Saint James

PO Box 27683, Los Angeles, CA 90027

To date, over 20 museums and galleries carry the work of this international award winning artist. Her current "Cultures" series depict several countries of the world. Television exhibitions include Essence, Weekend Gallery, In Studio and the Everywhere Show. She is also available for commissions, and offers limited edition prints.

Comorian Wedding - Mbili. Oil, 24 x 36.

Hagop Sandaldjian

507 W Lincoln Ave., Montebello, CA 90640

Represented by Barakat, 429 N. Rodeo Drive, Beverly Hills, CA 90210

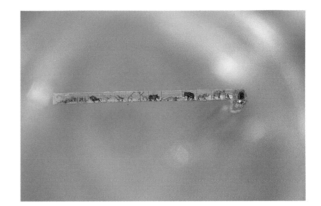

"Animals" is carved on a strand of hair 1/2" long covered with a layer of glue. This miniature technology, I believe, is not only an unusual art form, but its applications can be invaluable in many fields. A bunch of grapes, a statue of Napoleon and others placed in the eye of a needle, these creations of mine confirm my belief in this technique.

Animals. Mural.

James Sanders

2066 Lyric Ave., Los Angeles, CA 90039
(213) 661-6753

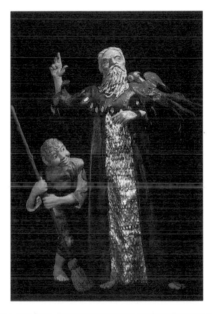

Sanders has worked as a commercial artist for 15 years, primarily in TV. In 1984 he won an Emmy for his art work. He has had a wide range of experience in all media but his favorite is sculpting. Currently expanding his career as a fine artist, he is accepting commissions for large works for public spaces and small works for reproduction in bronze.

The Sorcerer's Apprentice. Sculpture. 37 x 22 x 15. Private collection.

R. Schofield

PO Box 10561, Tampa, FL 33679

Represented by Capricorn Galleries, 4849 Rugby, Bethesda, MD 20814

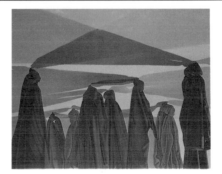

MFA degree from University of South Florida. Has exhibited all over the country. Solo shows in Washington, DC; West Liberty, West Virginia; Evergreen, Colorado; Cambellsville, Kentucky; various sites in Florida. Works in many public and private collections including collections in Germany, Guam and Malaysia. Many prizes received in juried competitions. Currently full-time painter.

Dapper Druids. Oil, 48 x 60. Artist's collection.

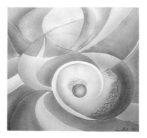

Carl Schumann

23 Center Street, Milford, CT 06460

Carl Schumann presently heads his own design studio, creating original collages and paintings as well as producing award winning commercial graphics. His unique work has been presented to members of the NY Mets and NY Yankees organizations and featured at various shows in New York City and New England. Carl is a graduate of the School of Visual Arts, NYC.

Driven. Graphic, 24 x 18.

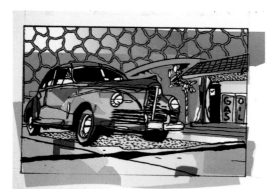

Lynn Diana Shepherd

PO Box 888328, Atlanta, GA 30356

Education: College of Architecture, Georgia Tech.
Exhibited: New York, Georgia, Maryland, Alabama, Texas and Europe.
Media; watercolor, airbrush, pastels on collagraph.
Art Philosophy: new forms to express inner content.
Portfolio: abstract designs, graphics, architectural compositions and original prints.

On Circle. Collagraph, 20 x 20. Private collection.

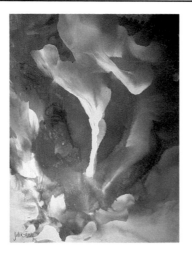

Yvette M. Sikorsky

PO Box 146, Lake Mohegan, NY 10547
(914) 737-5167

Born in Paris, France. Graduated there. Held designing position. Wallpapers, murals, textiles and fine art in USA. Exhibited for years in France. Receive honorable mention in 1965. Bronze medal in 1973 from City of Paris for watercolor. Was at the salon des nations 1985. Exhibited 14 paintings made some video and many one man shows. Exhibits in this country and abroad.

Mushroom. Acrylic, 36 x 48. Artist's collection.

Nancy L Steinmeyer, aka NLSKUH

1400 W. Thorndale #3E, Chicago, IL 60660

Represented by Hoy Horwich, 226 East Ontario, Chicago, IL 60611

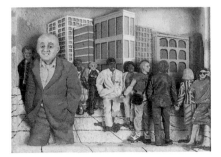

Graduate Western IL U 1974-1978: Rockland Centerr for International Studies, Colchester, Eng 1984. Art Lecturer sSo IL High Schools., 1974-1982; one woman shows include Kean-Mason Gallery, NYC, 1982, Springboard Gallery, Springfield, IL, 1982; exhibited in group shows. Joy Horwich Gallery, Chicago, 1985; Sioux City Art Center; Iowa, 1983; Reinner Art Gallery, Carlingville, IL.

Lunch Break. Paper relief, 26 x 32 x 3.

Silja Lahtinen, Nee Talikka

5220 Sunset Trail, Marietta, GA 30068

Represented by Ariel Gallery, 76 Greene St., NY, NY 10012

Born in Finland. BA and MA from Helsinki University. BFA Atlanta College of Art, Atlanta, GA; MFA Hoffberger, Baltimore, MD. Studio in Marietta, GA. Exhibits in the US and Finland. Searching for the answer to what is a painting about . My work is my prayer.

Cesium in My Blood O My Love Altamira or Today (The Morning). Acrylic, 72 x 65. Artist's collection.

Phil Tice

4422 Alice Way, Union City, CA 94587

Represented by Will Torphy, 470 Fillmore, #3, San Francisco, CA 94117

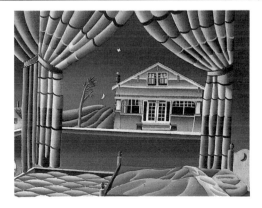

BFA and MFA at California College of Arts and Crafts, Oakland, CA 1968 and 1970. One person and group shows at the Hayward State University Gallery 1985. Jehv-Wong Gallery, San Francisco, 1981. IPD Gallery, San Jose 1977. Syntex Gallery, Palo Alto 1972-1976. Hern Gallery, Palo Alto 1973. Nahl Hall, Calif. College of Arts and Crafts, Oakland 1968.

The Green Pillow. Acrylic, 16 x 20. Private collection.

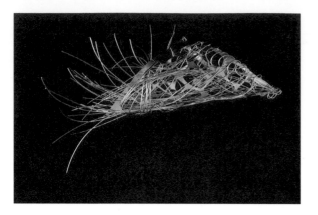

Alexandru Usineviciu

104-50 102 Street Apt. 1A, Ozone Park, Queens, NY 11417 (718) 845-5984

Born in Romania in 1950. Degree: Master of Art 1976. Major: Scultpure. Exhibited in Bucharest and Paris (1976-1982). Participated in the Sculpture Camps from Magura (1977) and Arcus (1978) in Romania. Monumental scultpure: 1979 , Romania stainless steel. Art instructor in Romania since 1983. His works are represented in private collections in Paris, Montreal, Toronto, New York.

Insect. Metal brass, 22 x 15 x 12. Artist's collection.

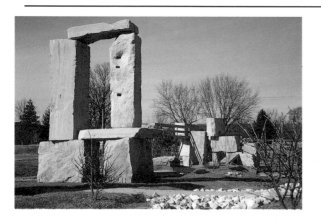

Verdella - Karen W. Brown

83 Suffolk Street, Charleston, SC 29405

BS in Music, Claflin College 1978. Post-graduate study in Art at the University of South Carolina. Taught art and music from 1978 to 1983 in the public school system. Exhibited in the 1984 Salon Des Nations a Paris in Paris, France. Artist-in-Residence for the City of North Charleston in 1986. Affiliated with the South Carolina Arts Commission.

Shining Through. 30 x 40. Artist's collection.

Mark A. Wallis

289 S. West St., Spencer, IN 47460

Born in Hawaii. Raised in California. Received BFA from Kansas City Art Institute 1978. Received MFA in sculpture from Indiana University Bloomington, 1983. Living in small town with artist wife Carol Sandberg and two children. Currently doing commission work and custom wood furniture.

Untitled. Limestone. Private collection.

Raphael Lyle Warkel

Box 772, Carmel, IN 46032

Represented by Traci's Recollections, Box 772, Carmel, IN 46032

Realist oil Painter and illustrator born in Phil. Subject matter includes pick-up art, supernatural phenomena, sports and works concerned with the complex interrelationships, ambiguities and discordant aspects of modern life. Symbolism is often used to solidify composition and to expand essence.

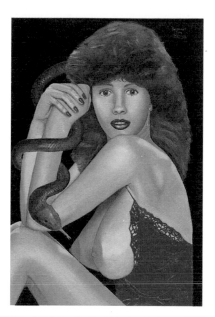

Brunette with Snake. Oil, 24 x 18. Private collection.

Donna Wise

77 Mowat Ave, Unit 412, Toronto, Canada M6K3E3

Abstract expressionist works with acrylic on large canvases sizes range 5' to 14'. Major solo exhibitions at Artworks International, North York; Bonnie Kagan Gallery, Toronto; Shayne Gallery, Montreal; Spectator, Hamilton; Hakku Gallery, St. Catherines. Member Society of Canadian Artists.

Red Dynasty. Acrylic, 54 x 77. Private collection.

Connie L. Wright

651 22nd Ave., San Francisco, CA 94121
(415) 221-9916

Represented by Ariel Gallery, 76 Greene St., Soho, New York, NY 10012 (212) 226-8176

Connie was born in Iowa, and lives in California. She is devoted to her life's love, painting; showed in several exhibitions in USA and Europe. Graduated at San Francisco Art Institute with a BA in painting, 1981. Her work is poetic and lyrical, colors that flow, reaching well below the surface, an abstract diary depicting her life.

Cancer Doll. Pastel Acrylic, 22 x 24. Artist's collection.

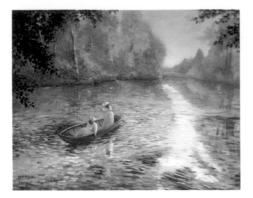

Yumi

5700 Baltimore Dr., #40, La Mesa, CA 92042
(619) 697-0465

Represented by Gallery 384, 384 North Coast Hwy,
Laguna Beach, CA 92651 (714) 494-7963

Born in Tokyo, Japan. BFA at Keio University,
Tokyo. Studied at Academy of Fine Arts in San
Francisco. 3 years study in Holland. Won
numerous awards. 1st Place at International Fine
Arts Competition in 1981. Exhibit at Gallery 384,
Laguna Beach and Gallery Shin-Ya,
Kamakura, Japan.

Boating. Oil, 24 x 30. Artist's collection.

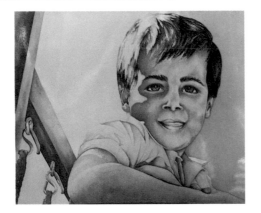

Karen J. Puleo

6337 West Fullerton, Chicago, IL 60639

Born and reside in the Chicago area.
Graduated from Barat College in 1983, majoring
in Fine Art. I have continued my education at
the Art Institute of Chicago and the University of
Illinois under the Smith Award and Masters
program. Painting allows me to create a world
that I perceive. Illustration allows me to weave
my passion for painting into my livelihood.

Jamie. Watercolor, 18 x 24. Private colleciton.

Mario H. Acevedo

1321 Colony Street, Flower Mound, TX 75028
(214) 539-1212

I am fascinated with the visual images that define
America. The subjects I depict range from
historical events to my current focus on modern
Americana. I use a variety of mediums and
techniques ranging from ink drawings to
watercolors to oil murals.

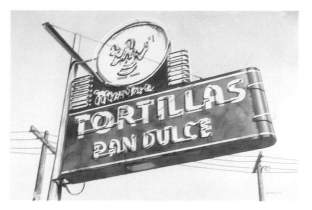

Martos Tortillas. Watercolor, 22 x 30. Private collection.

Norma Wade Albritton

4711 Woodview Street, Arlington, TX 76013

Born in Estelline, Texas. Studied art at Armstrong
State College in Savannah and Metro Tech in
Omaha. Membership in Art Associations in
Savannah, St. Louis and Omaha. Landscapes
and portraits in oil; also some sculpture. Logo's
and coat-of-arms. Striving to capture and
preserve moments in time that will strike a
responsive chord in the viewer.

Old Friends. Oil, 24 x 36. Artist's collection.

Richard J. Allen

PO Box 3153, Oakland, CA 94609 (415) 654-6600

Painter. Studied: California College of Arts and
Crafts, MFA 1969. Teaching: CCAC, Vista College,
Studio One, Oakland. Reviews: SF Chronicle
9/27/72, Art West 10/22/74. Currently owner of
Allen Art Services, offering a variety of services to
Bay Area artists, collectors, and business
community. Framing, paper restoration, fine art
french matting and hand coloring.

Peek-a-Boo. Graphite, 29 x 21. Artist's collection.

Floyd A. Alsbach

217 Emma, Slater, MO 65349 (816) 529-2423

The painting as a whole is built upon dynamic tensions which, ideally, balance. The mood created by combining these two opposing poles of the painting tradition is exponential in nature and could be described as a contemporary pathos. Most recent one person show: Blue Mountain Gallery, New York, New York.

As a Sign XIX. Alkyo, 16 x 24.

Mette Andenaes

5 Palmer Ave, Tiburon, CA 94920

I was born and educated in Norway. Two years ago I moved to California, where I have been working and studying art. I use oil or acrylic as medium and my paintings are impressionistic scenes mostly from San Francisco and the Bay Area. I have shown my work in many exhibits.

San Francisco Marina. Oil, 24 x 36. Artist's collection.

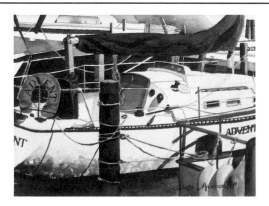

Colett J. Anderson

123 Lincoln St., Kane, PA 16735

Colette earned her BFA in Communications Graphics from Edinboro State University in 1982. Since then she has been a professional watercolor artist winning numerous awards including first place in realistic watercolor from the Allentown Village Society in Buffalo, New York. Her subjects vary from still life to portraits done in a representative manner.

Buffalo Waterfront. Watercolor, 20 1/2 x 23. Private collection.

Jack Anderson

622 Greenwich St., New York, NY 10014
(212) 242-0036

Represented by C. Scott Smith, 300 East 33rd St.,
Suite 15A, New York, NY 10016 (212) 889-1121

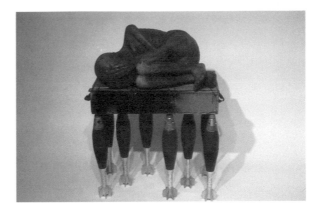

Jack Anderson was born in Easton, MD. He
studied sculpture at the University of Virginia and
has exhibited around the state and in
Washington, DC. between 1976 and 1979. In 1980
he moved to New York City and has exhibited at
White Columns, Hallwalls, Washington Square
East Gallery, Rocks in Your Head Gallery and the
Stafford.

Untitled Emaciated Child with 81 Millimeter Mortar Rounds.
Carved wood, 36 x 26 x 13. Artist's collection.

Anneli Arms

113 Greene St., New York , NY 10012

Born in New York City. BA, School of Art, Univ. of
Mich.; Scholarship, Art Students League, NY.
Latest one-person show: Exhibition Space, NYC
(Ingber Gallery), 1986. Group exhibits include
Detroit Institute. of Art; Riverside Museum, NYC;
Sculpture Sites, NY; Ingber Gallery, NYC, among
many others. Paintings, reliefs, sculpture and
etchings in numerous private collections.

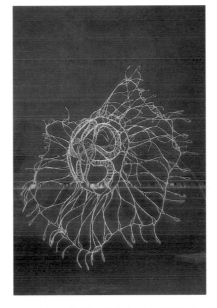

Jellyfish. Wire, acrylicm, 60 x 60 x 60. Artist's collection.

Jirayr Asatrian

5439 Russell Ave., #8, Los Angeles, CA 90027

Born in Cairo, Egypt. Graduated Yenevan
University of Fine Arts with a Masters Degree
(USSR). From 1964-1976 Group Exhibitions in
Moscow, Leningrad, Kiev, Madrid, Rome, Paris.
Winner of Jubile Gold Medal from Presidium of
Union of USSR. Certificate of Honor from USSR
Artists Society and many others. Since 1977
resides in USA. Works as a landscape and still life
artist.

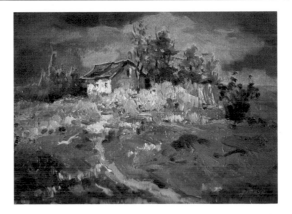

The Light of Summer. Oil, 20 x 16. Artist's collection.

Joy D. Baker

442 West 57th St., New York , NY 10019

Recent work: One Woman Shows: 1987-Citibank, NA, 40 West 57th St, NYC; 1986-The Atrium Club, NYC. Group Shows: Esta Robinson Contemporary Art, NYC, 1985; Pascack Valley Art Show, Woodcliffe, NJ; Gallery of American Artists, NYC, 1984; Art Expo, NYC. Representation by Hammer Galleries. NYC corporate collections: Trasconsult International, Saks Fifth Ave., Baily Banks Biddle.

Tranquility. Acrylic, 50 x 56. Artist's collection.

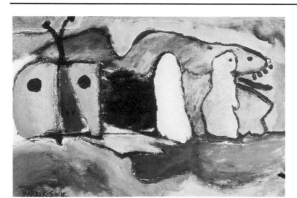

Cynthia Barker-Sucik

PO Box 94, Lowes, KY 42061

Born in Dallas, Texas; now resides in Kentucky. Barker-Sucik is the recipient of eleven regional awards and one national award for painting, drawing, photography and mixed-media collage. Participant in 23 exhibitions, 9 invitationals, 11 juried regionals, 1 national exhibition and 1 solo exhibit. Paintings hang in private collections in 7 states.

The Unveiling of the Universe. Acrylic, 15 x 23. Artist's collection.

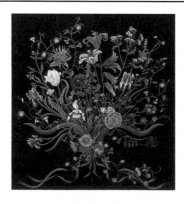

Carol Tudor Beach

35 Everit St., New Haven, CT 06511 (203) 777-9004

BFA RISD Illustration 1981. Worked for Warren Platner Associates Architects 1981-1986 as in-house artists. Photo schown is of project done while employed by Platner. Currently working independently for private clients doing murals including florals, abstracts, and landscapes. Shows in New England area.

Wildflowers. Acrylic, 40 3/4 x 44 1/2. Private collection.

Ken Beckles

126 Fifth Avenue, New York, NY 10011
(212) 691-2641

1986 Exhibit: Neon Graffiti, NYC. 1985 Exhibit: M. Darling Gallery, NYC, Itokin Plaza NYC, Barbara Brathen Gallery, NYC. 1984 Exhibit: Danceteria, NYC. 1983 Exhibit: West Broadway Gallery, NYC. 1981 Exhibit; Keane Mason Gallery, NYC. 1980 Exhibit; Tower Gallery, NY. 1978 Exhibit. S.U.N.Y. NY. 1978 Creative Artists Public Service Grant, NYC.

Mirage. Acrylic, 38 x 92.

Gaye Elise Beda

317 Second Ave., Apt #16, New York, NY 10003

Represented by Linda Galietti, 325 East 64th St, Suite 504, NY, NY 10021

My Paintings are done in acrylic paints on fine linen. They are representational, yet broken up by clear, clean color in an almost impressionistic manner. In my work, I strive to create atmospheric uniqueness through the sense of strong basic colors. I use these theatrical bright colors to achieve new and intriguing effects with light contrast.

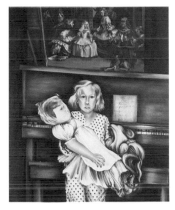

Little Girls. Acrylic, 40 x 48. Artist's collection.

Art Beery

378 Lynn Dr., Marion, OH 43302 (614) 383-5353

Creator of Spaceforms since 1959. Awarded Oscar d'Italia 1985 by Accademia Italia. Exhibits many both Internationally and Nationally. Contemporary Americans 1972 in Paris. Awards many National & Regional. 7 one-man exhibits. Member water color USA Honor Society. Spaceforms are shapes of beauty of curves and color. Most are mobius. They have only one edge and one surface.

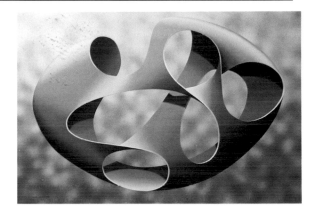

Black and White Mobius 1977. Oil, 36 x 24. Private collection.

Norma Je-ann Beery

378 Lynn Drive, Marion, OH 43302 (614) 383-5353

Fine Arts painter - teacher. Originator of realistic distortions. Studied Columbus College of Art-Design, Columbus, Ohio. Media - watercolor, oil, pencil. Specializes in landscape, portrait, still life, realistic distortions. Awards include juried shows, festivals. Commissions from major industries (Coca-Cola, Elk Head Oil, Britton Air Freight, State of Ohio, Mt. Aloysuis). Work in private collections worldwide.

Brass Vase and Butterfly. Watercolor, 15 x 17.

Ferron Bell

PO Box 345, Fire Island Pines, NY 11782

Represented by The Gallery at Lincoln Center, NYC, NY 11782

Ferron's leprecaunish frame of mind and often magical-sense of whimsy, jump off the canvas at you. Each painting is a conversation piece. He was recently photographed by National Geographic Magazine (March 1986). Surrealism and pun are his specialties.

Comet Toast 2. Mix Media, 18 x 28. Private collection.

Gigi Benanti

7 Morgan Ave., Norwalk, CT 06851 (203) 852-1557

Gigi is a mixed media artist who paints on fabric in a watercolor style. She then stitches on top of needlework, adding beads or bits of glass in a semi-abstract way. She also draws with pencil or marker on the fabric. She favors water or dancers as subject matter. All are framed. She has won many awards locally and nationally. Gigi is listed in Who's Who.

Self-Portrait. Mixed media on fabric, 15 x 15. Artist's collection.

Margaret Pater Bennett

5607 Sobrante Ave., El Sobrante, CA 94803

A painter printmaker, Margaret has designed and cast in silver pewter and gold custom objects and jewelry including set stones. She shows nationally and internationally, is proprietor of a giftware business and has created a unique Renaissance figured tableware service. Chosen designer of Mercedes Benz Centennial Commemorative 1986, and named to Who's Who in California.

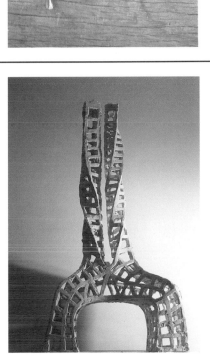

Serving Set: 3 detailed sculptural figures (Renaissance). Cast metal, 2 1/2 x 5.

Tiberiu K. Bente

118-60 Metropolitan Ave., #6B, Kew Gardens, New York 11415

Represented by Kristen Richards Gallery, 123 East 54th St., #2D, NY, NY 10022 (212) 888-7618

The elements of Tiberiu Bente's artistic vocabulary undergo a permanent metamorphosis between materials and dimensions, colors, and light, thus justifying a closer relation established between an artificial meditating universe and the interlocking cells of a natural system.

Candels. Bronze, 44 x 22 x 11. Artist's collection.

Sandra A. Betelak

2521 East 16 Street, Brooklyn, NY 11235

Born in Syracuse, New York where I studied graphic art. Moved to New York City to receive illustration degree at Fashion Institute of Tech. Works as freelance illustrator. Studied painting at Parsons and Art Students League. Commissioned for numerous portraits. Medias include oil and mixed media, pastel, pencil. I work in the classical technique, gesso on wood with layered glazes.

Sunday Afternoon With the New York Times. Oil, 36 x 26. Private collection.

Marlene E. Bezich

201 Tudor Lane, Middle Island, NY 11953

Represented by Morin-Miller Gallery, 119 W. 57th St, #805, New York , NY 10019

Began her training under Audrey Marlow, PSA. Presently is under the guidance of portrait artist Rafael De Soto. She enjoys working in many medias, particularly oils and pastels. Is represented by Morin-Miller Gallery, NYC and Ward-Nasse Gallery in Soho, NY. She seeks to utilize color to its fullest extent and to stimulate the viewer whenever possible.

Katay. Pastel, 18 x 24. Artist's collection.

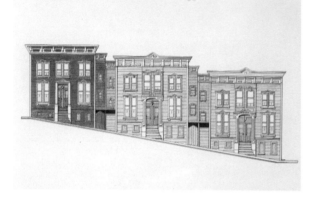

Larry Blake

2002 Pierce St., San Francisco, CA 94115
(415) 567-5168

Represented by Publication Arts-Pan, 717 Market St., San Francisco, CA 94103
(415) 777-5988

Larry Blake is a working artist involved in projects covering a wide variety of subjects. He is largely self-taught with some of his finest work being architectural. He is presently designing and illustrating a book on kites that will be distributed internationally. He is a South Bay Area Native.

Pierce St.. Watercolour, 21 x 30. Artist's collection.

E. Jean Boger

2155 Warrington Ct., Colorado Springs, Co 80918

Artist E. Jean Boger is a painter of mountains and odd artifacts. She captures on canvas the tone and mood and depth and splendor of our rocky Mountains country. Jean's research often takes her to remote areas of the Rockies to make sketches and color studies from life.

Decan's Bench - No Admittance. Oil, 24 x 36. Artist's collection.

Diana Boulay-Dube

82 Fieldfare Ave., Beaconsfield, Quebec
Canada H9W 4W6

Education: The Montreal Museum School of Art
and Design 1974- 75, University of Quebec at
Montreal 1981, BFA. From 1982 Solo Exhibitions:
Gallery Nouvel Age, Danville Museum, Virginia,.
14 Sculptors Gallery, Soho, NY. Many juried
exhibitions in Montreal and vicinity. Winner of
many Canadian awards. She uses plastic
discards to make the public aware of their magic.

Witness. Found objects, 8' x 3' x 2'.

Frank Lynn Brevard

PO Box 76058, Washington, DC 20013

Became interested in photography at age 9
through local Recreation Department. Persued
interest working on the newspaper, yearbook
and public relations staffs at Morehouse College
in Atlanta, Georgia. Works have appeared in
several of Photographer's Forum's, Best of
Photography Annuals and several literary
magazines. Favorite types of photography
include abstract and scenics.

Shadow Ascent. Photography, 11 x 14. Artist's collection.

Ernesto Briel

353 W. 44th St. 5B, New York, NY 10036

Represented by Valerie Miller & Assoc., 202 North
Larchmont Blvd, Los Angeles, CA 90004

Born: in Havana, Cuba. American resident since
1980. He has been exhibiting his art since 1966, in
Cuba, USA, Mexico, Spain, Monaco, etc. His
works are included in the collections of the
Museum of Fine Art of Havana, Cuba and private
collections around the world.

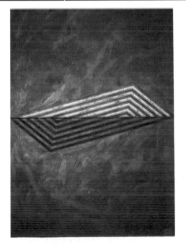

Knite of the Gold Age. Oil, 70 x 48.

David Bufano

542 Pacific St., 2R, Brooklyn, NY 11217
(718) 858-0830

One-Man Shows: 55 Mercer St., NY, NY, 1987; The Pharmacy, NY, NY, 1987; Off Center, Chicago, IL 1983; Midway Studios, Chicago, IL, 1983. Group shows: Inroads Gallery, 1983; Iowa Gallery, Evanston, IL , 1982. Education: MFA, University of Chicago, Chicago, IL 1983; BFA with highest honors, University of Texas, Austin, Texas, 1980.

The Silence of Orpheus. Oil, 72 x 84. Artist's collection.

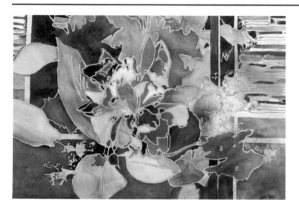

Joan A. Burr

PO Box 1474, Winslow, AZ 86047 (602) 289-3945

Represented by Fleet Art Salon, Hozho Center Highway 179, Sedona, AZ 86336 (602) 282-1823

Art Degree, Rose College Oklahoma. Studied Louisiana Tech, Scottsdale Artist School, Norton Gallery School of Art. Numerous seminars with noted artists. Represented by the Art Salon in Sedona, Arizona, Ariel Gallery in Soho NYC and Burlingame Gallery in Taos, New Mexico. A juried member of Arizona Art Guild and Arizona Watercolor Society.

Floral Fantasy. Watercolor, 22 x 30. Artist's collection.

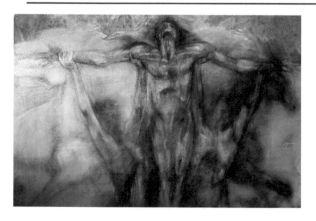

Barbara Burritt

103 Cheda Lane, Novato, CA 94947
(415) 892-2347

BFA honors Minnesota College of Art and Design, Mpls, MN. Artist unveils imagery from the sub-conscious. As in a dream-state, this intuitive exploration becomes the palette, as auras solidify into colors on the canvas. Vapors of the imagination congeal; a painting is realized.

Blood Sacrifice. Oil, 72 x 84. Artist's collection.

Linda Butti

1000 Clove Rd, Staten Island, NY 10301

Represented by Nancy Stein, 340 W. 57th St.
Studio 5H, NY, NY 10019

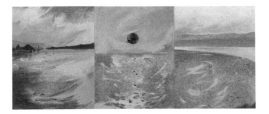

Butti is a native New Yorker who explores her
environment in a semi-abstract painterly style,
with water as one of her main vehicles for
exploring visual language. Butti exhibits nationally
and has had several solo shows in NYC, most
recently Ward Nasse, Newhouse Gallery and
Rousimoff's Art Showcase. She received her
MFA from Brooklyn College.

Ferry Series #26. Oil, 26 x 58. Private collection.

Wendy Cadden

2222 9th Avenue, Oakland, CA 94606
(415) 532-4778

Represented by Kate Dole, PO Box 1274,
Oakland, CA 94604

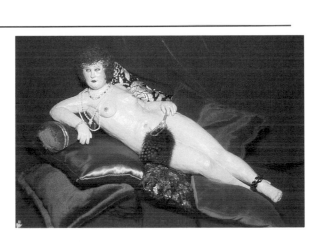

Cadden, a printmaker and painter, has been
exhibited widely Including Ii Cabo Erio Print
Biennial, Brazil, and Elaine Benson, NY. Her work
has been featured in many periodicals, books
and record albums. She is her work, she lives her
art. The electric energy that surrounds and
connects people is made manifest.

Wailing. Oilbase ink, 22 x 33. Private collection.

Sue Carey

1700 Bush St., San Francisco, CA 94109

Born in NY. Studied art at Parsons School of
Design, School of Visual Arts, Traphagen School
of Design. Work displayed at Tiffany's and
Galleries in NY and SF. Recent exhibit resulted in
entry in the published "Art Achievement Awards"
through Artists Society International.
Compositions in nationally circulated
publications. Pieces in private collection.

Martine. Mixed Media, 14 x 4 x 4. Artist's collection.

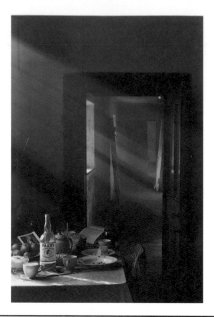

Michael A. Carnevale

1901 Greenwood Street, Pueblo, CO 81003

Landscape Photography. Traveled in Ireland since 1979. Exhibits in New York State and Colorado. Included in permanent collection of New York State Museum at Albany.

Clare Island Lighthouse, Ireland. Photography, 8 x 10. Artist's collection.

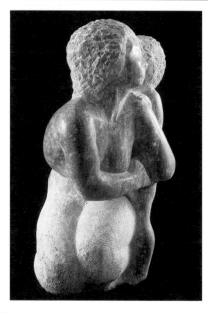

M. C. Carolyn

316 Elm Avenue, Takoma Park, MD 20912
(301) 270-8094
Represented by Wallace Wentworth, 2006 R Street, NW, Washington, DC 20009
(202) 387-7152
Sculpture that translates the solidity of stone into metaphors for the questions, struggles and aspirations of life. She is one of the few direct carvers in contemporary art. An accepted proposal - Peach Park/Sculpture Garden, TP, is a US first and M.C. Carolyn is the first woman to create such a project anywhere in the world. BA, UC Berkeley. Grad SF Art Institute.
....*Up: The Words of Childhood.* Tenn. Marble, 33 x 17 x 17. Artist's collection.

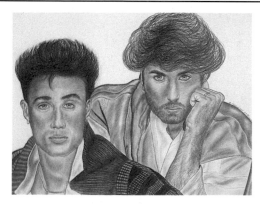

Bertha C. Cartwright

105 Keer Avenue, Newark, NJ 07112
(201) 923-8988

I graduated from Rutgers University in 1984 with a BA degree in Visual Arts. Since that time, I have been employed in the retail field for the sake of an income. I am presently building a new portfolio of fashion illustrations in hopes of getting into that field. I enjoy drawing portraits of well-known personalities which represents 90% of my present portfolio.

Wham! Pencil, 18 x 24. Artist's collection.

Gary G. Champagne

973H2S Rte 1, Kewadin, MI 49648 (616) 599-2644

Award winning artist Gary Champagne has participated in art shows throughout the state of Michigan. He enjoys working with subjects and situations typical to his present and past, capturing things as they are, striving for the human element in his art. Commissions welcome.

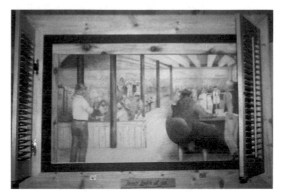

Here's Lookin at Ya. Colorpencil, 47 x 24.

Phillip P. Chan

5225 Edgeworth Rd., San Diego, CA 92109

Represented by Valerie Miller, 202 North Larchmont Blvd, LA, CA 90004

My figures are connected to the cosmic dialectic of Life/Death, absent from the axes of Heaven/Earth. Attempting to recover the four fold ontology of Being on the two fold tightrope of contemporary existence. My figures leave the trail of vulnerability, suffering, scarification, temporality, and alienation embedded within its sexuality.

Untitled. Oilstick, 28 x 22. Artist's collection.

Sandra "Jangmei" Chang

132-67 Avery Avenue, Flushing, NY 11355
(718) 461-7022

She graduated from Columbia University with a BA. She is a fantasy illustrator, comic artist and computer programmer. Media: Oil, pen and ink, and computer graphics.

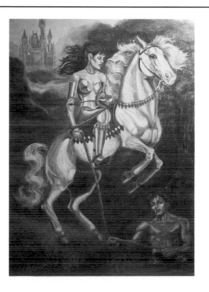

Lady On Horse. Oil, 20 x 15. Artist's collection.

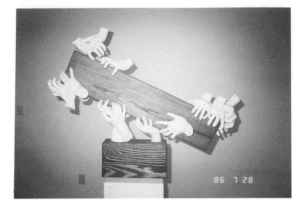

Fay-Long Chen

17621 Webster, Irvine, CA 92714 (714) 733-1934

Represented by Ettinger Gallery, 2222 Laguna Canyon Road, Laguna Beach, CA 92714 (714) 497-3309

I have been a chemical engineer for four years. It has always been my ultimate desire to become a sculptor, thus the journey to USA to pursue my dream of creation. "Art is not a choice, but a way of self-realization; my original abode is here, yet in the course of creation, art has brought excitement to my soul and labor for my hands. This is my finest hour."

Limited Edition #1 of 1. Wood & plaster, 40 x 10 x 33. Artist's collection.

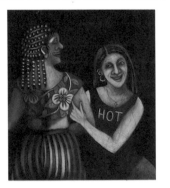

Rena Church

2245 W. Shakespeare, Chicago, IL 60647

Rena Church attended the University of Illinois at Urbana and went on to the School of The Art Institute of Chicago where she graduated in 1983. The Neighbors is part of a series depicting the people of her neighborhood, who are rapidly being driven out by "gentrification."

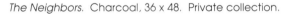
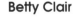

The Neighbors. Charcoal, 36 x 48. Private collection.

Betty Clair

HC1 Box 116A3, Spring Branch, TX 78070 (512) 885-7665

Represented by Hearts Desire Gallery, HCR3 Box 681-M, Canyon Lake, TX 78130 (512) 964-2711

A basically self-taught artist, taught portraiture in oils and pastels over a decade and studied under well known artists, including Henry Wilson of Trinity University, and John Squire Adams, both of San Antonio, Texas. Her paintings of people show much realism, as if she almost breaths life into her subjects.

Portrait of John Wayne - A Legend. Pastel, 18 x 24. Artist's collection.

Susanne Clawson

5093 Velda Dairy Rd, Tallahassee, FL 32308
(904) 893-5656

Represented by Jackie Chalkley, 3301 New
Mexico Ave, NW, Washington, DC 20016

The artist designs and produces original wall
pieces in 2 media: handmade paper and fiber.
The paper fibers are dyed by hand and mixed
with silk threads, pearlescent pigments and
iridescent chips which become embedded in the
paper. The fiber works are sculptural and made
from wool, silk and rayon.

Xinxim por Cima #2. Handmade paper, 17 1/2 x 32 1/2. Artist's
collection.

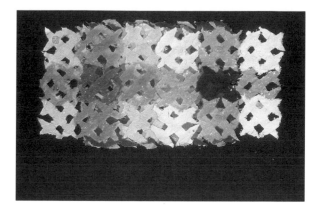

Debra A. Cline

1219 51 Avenue East 171, Bradenton, FL 33507
(813) 758-8717

Represented by Eye of the Beholder, 8201 South
Tamiami Trail, Sarasota, FL 33583 (813) 923-4696

Debra Cline was born in Chicago, Illinois 1957. She
attended the University of South Alabama and
later transferred to Ringling School of Art where
she graduated in 1979. Her art is on display both
nationally and internationally. She is currently
employed as art director at Snelling and Snelling
International Headquarters in Sarasota, FL.

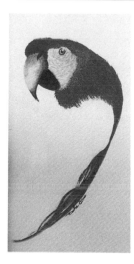

Tropical Feathers. Watercolor, 8 x 12. Artist's collection.

Ellie Cook Cline

PO Box 13013, Salem, OR 97309

Represented by Lincoln Art Gallery, 620 NE Hwy
101, Lincoln City, OR 97367

Attended Art Students League, NYC. Studied in
Europe; influenced by G. Cherepov, D. Greene.
Artist member of American Artists Professional
League; Associated Member, Western Artists of
America; NSTDP. Author of Three Art Instruction
books. Media: oil, acrylic, watercolor. Realistic
painter as well as alla prima, on location
impressionism.

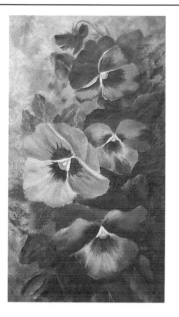

Pansies IV. Oil, 12 x 24. Private collection.

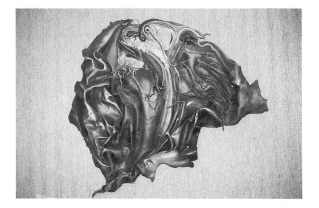

Ronald Ross Cohen

4 West Bayview Ave., Pleassantville, NJ 08232
(609) 641-2368

Represented by Jay Piercy, 32 East Bolton Ave., Absecon, NJ 08201

Works in many mediums, most noted for advancing leather as a fine arts medium. Ross creates free standing realistic figures, abstract and bas-relief. Exhibitions in Paris; Cornell Museum of Art, Nabisco USA; History of Leather Museum; Coach Leather Ware. Collectiors: Coach Leatherware, NYC; Sailor Gallery, NJ; Claridge Casino Hotel, Atlantic City.

Dreams. Leather, 48 x 48 x 6. Artist's collection.

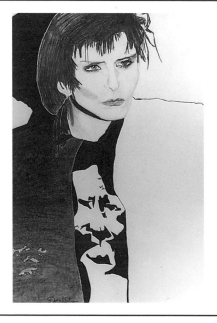

Donna J. Conley

221 E. Camelback, Suite 1, Phoenix, AZ 85012

I began creating early in my childhood. By 1982 I became dedicated to my art. I am interested in capturing obvious images, as well as the subtle ones found in the shadows, and in the way the light plays. Am seeking representation, and plan to work free lance - illustrating. I am a graphic design graduate and also sell original "Freedom" designs as wearable art.

Woman with Life. Mixed, 18 x 24. Private collection.

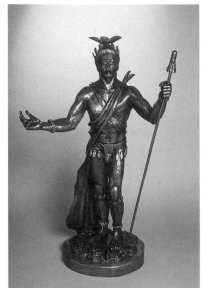

Bradley J. Cooley

PO Box 11, Lamont, FL 32336

I am a historian by heart and feel that by looking into the past one may foresee the future. My final goal being that someday in the future one may look at my historical illustrations and see the past.

Welcome to the New World. Bronze, Edition of 30, 37 x 16 x 10. Artist's collection.

Lois Coren

2613 Lincolnwood Dr., Evanston, IL 60201
(312) 869-6192
Represented by Goldman-Kraft Gallery, 300 W.
Superior, Chicago, IL 60610

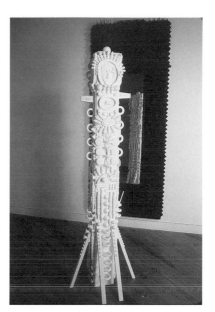

Lois draws and sculpts totems and wall reliefs.
They are done in mixed-media and found
objects on wood and painted in acrylics. Her art is
influenced by the Indian art and symbols of North,
South and Central America and composed of
personal shamans and symbols. In the collection
of Kemper Insurance, McDonald Corp., Citicorp,
Amoco.Hereward Lester Cooke Foundation Grant
Award.
Reflected Aparthied (2-pieces). Mixed media on wood,
mirror totem, 83 x 32 x 3 & 60 x 21 x 17. Artist's collection.

Gary J. Cote

24 Curtis St., Marblehead, MA 01945
(61/) 631-8824

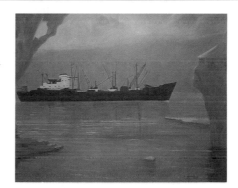

Gary was born in Salem, MA. He studied
illustration at the Butera School of Art in Boston
from 1980 to 1983. He has been working as an
architectural illustrator from his home studio since
then.

Arctic Freighter. Oil, 24 x 30. Artist's collection.

Jo-Lyn Craig

PO Box 2110, No. Vassalboro, ME 04962
(207) 873-4907

Represented by Judy's Art Gallery, Main St.,
Fairfield, ME 04937 (207) 453-2880

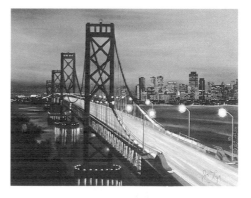

Born Maine., AA St. Petersburg Jr. College,
Florida. Numerous awards and exhibitions. Still
lifes featured and represented in NY by Ariel
Gallery. Work is taken from modern subjects and
painted after the style of the masters. Work has
been described as Gothic in character with use
of vivid color. Available for commissions.

Bridge. Oil, 24 x 30. Artist's collection.

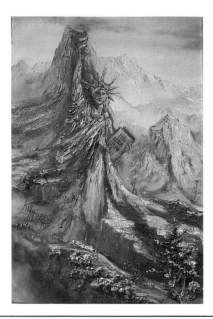

Lydia Darvas

1111 NE 151 Street, N. Miami Beach, FL 33162
(305) 949-5611

Graduated Comenius University, Fine Arts, Bratislava, Czechoslovakia. Won 75 awards. Held 29 one person exhibitions. Was presented several times on Miami TV. Member of the Czechoslovak Society of Arts and Sciences and the National Museum and Gallery registration Assn, Washington, DC and active judge in arts. Style - unusual combi nation of abstract, impressionism and surrealism. Shown piece is in Grand Canyon-Bicentennial collection.

Liberty to the Whole World. Oil, 30 x 40. Artist collection.

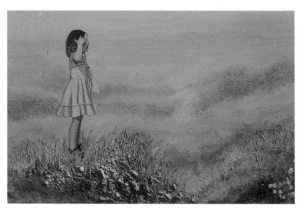

Olivia Darvas-Novak

13765 SW 147 C #3, South Miami, FL 33186
(305) 232-6882

Represented by Darvas Art Studio, 1111 NE 151 St, N. Miami, Beach, FL 33162 (305) 949-5611

Associate of Science Degree in Advertising Design 1979-1981 Art Institute of Fort Lauderdale, Florida. Included courses in illustration, ad design,painting, airbrush, product illustration, graphics,photography, TV productions, 3-D graphics, cartooning, and animation. Currently working as video graphic artist for TV and private commission through the USA.
View Point. Acrylic, 30 x 36. Artist's collection.

Zoltan Darvas

1111 NE 151 St.., North Miami Beach, FL 33162
(305) 949-5611

Born in Czechoslovakia. Became an American citizen in 1974. Zoltan began his art career working with his wife, semi- surrealists artist, Lydia Darvas. He then began to develop many unique techniques of his own in metal and wood sculpture, abstract paintings,.. Represented in private Bertmark collection.

Erotic Explosion. Multimedia, 22 x 28. Artist's collection.

(Ms.) Price Deratzian

1850 Crescent Court, Highland Park, IL 60035
(312) 432-3201

BFA Cornell University, 1986. Presently exhibiting paintings in Milan, Italy. Photographs have been published in Sports Illustrated, Sail, Playgirl, Sports Fitness and others. Will continue to paint as well as photograph for various clients and publications.

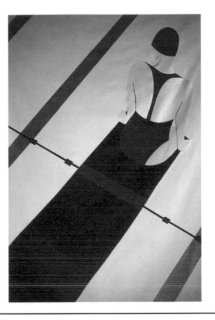

The Diver. Acrylic, 48 x 62. Private collection..

Joni Frankel Diskint

426 Hudson St., New York, NY 10014

I paint places: landscapes and interior scenes. My work is introspective. I try to evoke in the viewer a feeling of familiarity of place, allowing a mood to be created. Through the use of color, space and design, the viewer is beckoned and drawn into the scene. There is a sense of human presence: one's own.

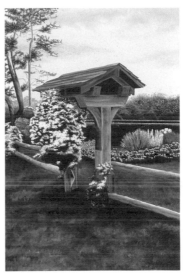

Georgica. Oil, 36 x 24. Artist's collection.

Susan Dobay

125 West Scenic Drive, Monrovia, CA 91016

Internationally recognized, Susan Dobay has been painting and exhibiting her work in the USA and abroad for the past 25 years. She has had 12 one man shows and participated in many invitational group exhibitions. Exhibitions abroad: Nairobi, Freiburg, Budapest (Contemporary Museum), Montreal, Munich. Her themes include the human experience and nature.

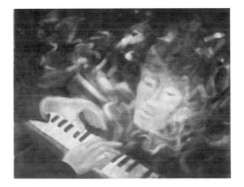

Pianist's Soul. Oil, 24 x 30. Artist's collection.

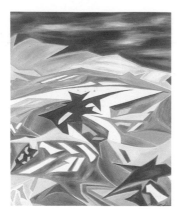

Elissa Dorfman

345 East 81 Street, New York, NY 10028

Represented by Dr. Leon Boyar, PO Box 1511, Wall St. Sta., NY, NY 10268

Art Students League, Pratt, New School. Exhibited in Japan, France, Brazil, Spain, Denmark. Artist in Residence, University of Maryland. Paintings, oil abstract, realistic, prints, watercolors.

Daytime Red. Oil, 34 x 40. Private collection.

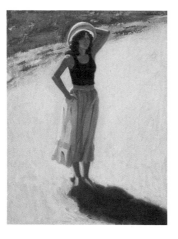

David A. Dozier

688 Main St., Metuchen, NJ 08840

BFA received from Layton School of Art and Design, Milwaukee, Wisconsin. Studied painting with Richard Goetz at Art Students League of NY. Exhibitions: ASL of NY; Galeria Botel'lo, San Juan, Puerto Rica;. Galeria Dorado Condado, Puerto Rica; Englewood Hospital NJ; Riveron Art Center, Union City, NJ. Work in studio in New York City. Live in New Jersey suburb.

Lissette at Cape Cod. Oil on board, 24 x 32. Artist's collection.

Frank Draper

615 Jean Marie Dr., Norman, OK 73069
(405) 329-4628

Studied at Univ. of Houston and Oklahoma City Univ. Works have been selected for honors and awards in many juried exhibitions and may be found in private collections and galleries in most southwestern states. My work is impressionistic using acrylic mixed media and collage. Currently preparing for a one man show in Oklahoma City.

Higher Elevations. Oil, 36 x 48. Artist's collection.

Donald Driss

201 West 79 Street #203A, New York, NY 10024

I arrived in NY over a decade ago and apprenticed with commercial artists. I consider myself to be a conceptualist. I absorb stimuli from my surrounding environment and redefine it in a two dimensional framework. My paintings are very colorful and geometric frontal perspectives of aircraft in which I create my images from my imagination and design specs.

No End. Acrylic, 24 x 48. Artist's collection.

Joey Drop

163 West 79th St, #3F, New York, NY 10024
(212) 799-3272

Photography has always been a passion with me but I didn't do my own processing until 1978. I was in the Air Force, stationed in Greece where I joined a photo club. The technical aspects of the medium fascinate me but communicating a concept simply and subtly without the use of "Instant creativity" is the challenge that keeps the passion alive.

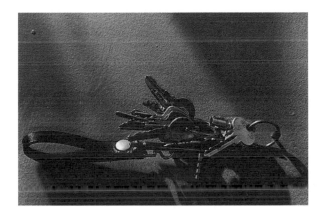

Keys. Photography, 8 x 10. Artist's collection.

Irene (James) Duffy

S.W. 300 Skyline, Pullman, WA 99163

Represented by NICA Gallery, N.E. 125 Olson, Pullman WA 99163 (509) 334-1213

Born in Chicago, Illinois. Currently completing Masters of Fine Art at Washington State University. Exhibited nationally in Boston, Los Angeles, Seattle and Lake Charles, Louisanna. Currently artist co-ordinator from Pullman Chamber of Commerce Palouse Visual Artists Projects, Pullman, Washington.

Point of View - Self Portrait. Etching BFK, 32 x 24. Artist's collection.

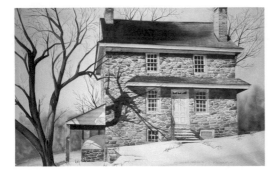

Bill Dussinger

324 Arch Street, Ephrata, PA 17522 (717) 733-7382

Bill is an Associate member of the Pennsylvania Society of Watercolor Painters. He is a frequent award winner and his work has been exhibited in the Dina Porter Gallery,Allentown, PA; The York Art Center,York, PA; Sheldon's Art Gallery, Ephrata, PA. Favorite subjects include buildingscapes and still life. He is available to do commission work.

John Chadd House, Chadds Ford, Pennsylvania. Watercolor, 38 x 48. Artist's collection.

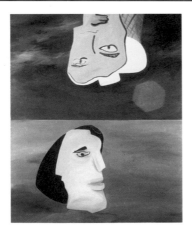

Alyse Green Edwards

105 1/2 Rose Avenue, Venice, CA 90291
(213) 452-9604

Born in NYC. BA UCLA in Fine Arts. MFA Program, Otis/Parsons, LA. In over 45 collections and exhibited in over 40 exhibitions, including "Emerging Artists-1986", Los Angeles. Owner and designer of "Ages" - original fused glass wall art and glass jewelry. Other work includes oil pastels on paper.

Decisive Mutation. Oil, 61 x 52. Private collection.

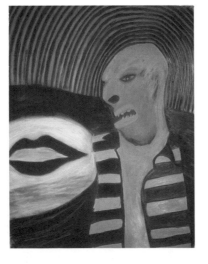

John Edwards

822 S. Wall Street, #201, Los Angeles, CA 90014

Self taught artist 44 years old. Shows: Anaheim Art Center, 1984; Lace Open Studio Tour, 1984; 1985 Satellite Gallery; 1986

Siren. Wax pencil on paper, 30 x 36. Artist's collection.

David L. Emley

2906 Rapidan Trail, Maitland, FL 32751

Born at Fort Benning, Georgia. Raised in eastern US and western Europe. BA Degree - University of Central Florida. Exhibited lightly in central Florida. Resided in central Florida since 1971. Style influences - A. Giacometti, Stonehenge, Easter Isles, NASA and new awarenesses. New language horizons formed in 1985. His style is knows as Davism (ambiguism).

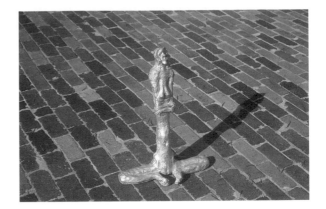

Lotus. Cast Aluminum, 26 x 19 x 8. Artist's collection.

Jean Emmons

PO Box 17354, Seattle, WA 98107

Represented by C. Hartness Fine Art, 83 S. Washington St., Seattle, WA 98104

After receiving a Masters in Printmaking degree from the University of Massachusetts in 1977, Emmons moved to Seattle and took up painting. Intuitive in approach, the paintings result from themes that percolate up from the artist's subconscious. Animals that traditionally symbolize transformation or rebirth are often a touchstone in the work.

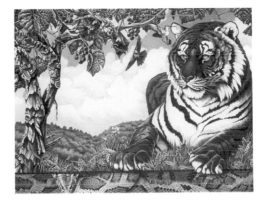

Quasi Tiger. Acrylic, 26 x 32.

Lars Erickson

122 The Riverway Unit 17, Boston, MA 02115

Lars Erickson is a 28 year old photographer. In 1975, while studying in Rhode Island, he originally produced etchings and serigraphs, then branched into photosensitive materials. Since 1983 he has concentrated on figure studies using standard B&W silver emulsions as well as hand-made papers. He recently relocated from SF to Boston where he currently works.

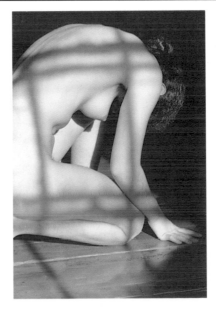

Nude. 1986 (120/163-4). Silver Emulsion, 8 x 8. Artist's collection

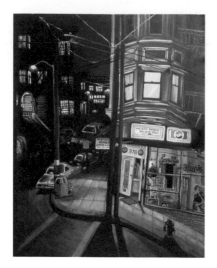

Elizabeth Eve

3394 Blair Dr., Hollywood, CA 90068 (213) 851-5164
(415) 566-9932

Exhibits include - Bay Area Seen II; SF Art
Commission Gallery; Freeman Gallery, Palo Alto;
Manuelitas, SF;Simard Gallery, LA; Vantage
Gallery, NY; 38-39 Arts commission festival SF;
Pacific Guilds Fall '86; Crocker Bank; Great
Western Savings. Awards - Artists Liasion,
Discover '84, Images & Issues Magazine. Award
of purchase SF Art Commission '87 for Police
Department Portraiture.

Mid-Nite Express. Oil, 48 x 36. Private collection.

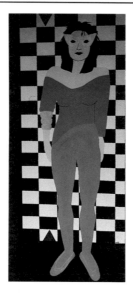

Diane Fabian Fabiano

22014 Craggy View Street, Chatsworth, CA 91311

Born in Boston/Graduate of California College
of Arts & Crafts 1976. Exhibits currently in several
independent galleries/previous solo and group
shows in LA/Art Beat Gallery/Prometheus
Gallery/Los Angeles Valley College/Orlando
Gallery/Brockman Gallery/Visionist Gallery/D.
Genard Gallery/Antioch Gallery West/So. Calif.
Contemporary Art Gallery. In Montreal, Canada
 Aubes 3935.

Troubadour. Acrylic, 28 x 72. Private collection.

Joseph Farleo

518 Porter St., Apt #6, Glendale, CA 91205
 (818) 500-7144

Graduated cum laude from Nazareth College of
Rochester, NY with a BA in studio art in 1985.
Worked as a freelance artist in NYC for 1 1/2
years before relocating to California. Currently
work as a freelancer doing both color and black
& white illustration. Specializes in colored
pencil, but is competent in other mediums as
well.

Lipps. Color pencil, 5 1/2 x 6. Artist's collection.

Kevin Farrell

61 Victory Boulevard, Staten Island, NY 10301

Studied architecture at Cooper Union and painting at The Art Students League of New York. Interested in science and history. My work primarily deals with the contemporary industrial urban landscape.

Sculptured Steel Hiding Greasy Hulks. Oil, 20 x 24.

Lisa M. Fedon

14 West Main Street, Pen Argyl, PA 18072

Exhibitions: 1985 Juror's Award Museum of Art, Carnegie Institute; 1987 Juror's Award Pittsburgh Center for the Arts; Butler Institute of Am. Art; Canton Art Institute; Boston Design Center; Westmoreland Museum of Art. Member: Assoc. Artists of Pittsburgh; Allied Artists of America; International Sculpture Center. Corporate & private collections in US/Europe.

Harold. Wire, misc, 74 x 30 x 24. Private collection.

K. Roxi Felfe

PO Box 470978, Ft. Worth, TX 76147

When I stare at a blank black page, I see an empty stage begging for lights, sensation, the echo of metal, the surge of raging chords, the roar of the audience, and most of all, the musicians in all their fire and grandeur. All of my art cries out to pay tribute to their world.

Height of Cadence. White pencil, 8 1/2 x 11. Artist's collection.

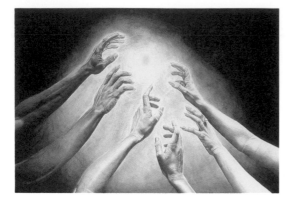

Patrick Finney

PO Box 91, Metamora, OH 43540

I am a surrealist painter and have been painting seriously since high school. My talents as an artist are mostly self-taught but I have been taking painting classes with an area artist to sharpen my skills. I try to make my paintings visually appealing and to make the viewer wonder about the meaning behind the surreal scenes.

Death at the Dawn of Paradise. Oil, 16 x 20.

Anthony C. Fletcher

2719 Speakman Place, Wilmington, DE 19802
(302) 764-7443

Represented by Ariel Gallery, 76 Greene St., Soho, NY 10012 (212) 226-8176

As a protector and preserver of the craft, I refuse to create art for the sake of beauty alone. By posing questions I intend to visually engage the viewer in conversation. In this work the hands of 3 people from different walks of life are reaching for the light. Light symbolizes happiness, wealth, love and understanding, God, etc.

The Quest for Light. Pencil drawing, 17 1/2 x 24 1/2. Private collection.

Paul T. Flynn, Jr.

55 Trinity Lane, Woodbridge, NJ 07095

Paul is a Navy Photographer working overseas. He lived in Japan for 2 years and has spent time in the Philippines, Australia, Thailand, China, Korea, Indonesia and Africa.

First Taste of Rock and Roll. . Photography, 5 x 7.

Jim Shung Kwong Fok

1S. 168 Ardmore Ave., Villa Park, IL 60181
(312) 629-4263

Born in Macau. Studied art in Hong Kong, London,
USA. Exhibited in Hong Kong & USA; Grove St.
Gallery, IL 1983; Springfield 66th National Exhibit,
Ma., 1985; Gruen Gallery Chicago 1985; Beverly Art
Center 9th Annual Exhibit, Chicago 1985; Spiva Art
Center 36th Annual Exhibit, Mo., 1986; Imagery
Gallery, IL 1987; Posner Gallery Wisconsin, 1987;
the 30th Annual Chautauque National Exhibit NY
1987.

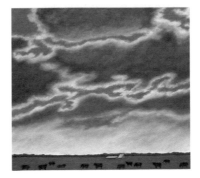

Sky-Landscape Series #1. Oil, 44 x 48. Artist's collection.

Diane Forde

Box 684, Wading River, NY 11792 (516) 929-3497

Represented by The Copley Society, 158
Newbury Street, Boston, MA 02116
(617) 536-5049

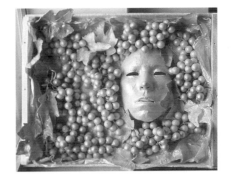

Studied at the School of Visual Arts, NYC; Rhode
Island School of Design. Her work has appeared
in galleries in Florida, New York, and
Massachusetts. Several paintings and designs
have been published as greeting cards for "Yo-
Chester Inc." The work shown here was selected
by the Copley Society for a benefit gala for the
March of Dimes, 1987.

Glorious Harvest. Plaster, 14 x 17. Artist's collection.

Nancy Fortunato, MWS

249 N. Marion St., Palatine, IL 60067

Represented by Landmarks Gallery, 231 N. 76th
St., Milwaukee, WI 53213

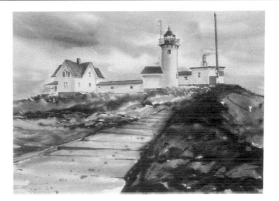

I use transparent watercolor because I find other
media too heavy for the natural world. Everything
in nature is mobile and so is watercolor. I select
subjects that the casual observer would overlook
and make them significant.

Eastern Pt. Lighthouse - Gloucester. Watercolor, 18 x 24.
Artist's collection.

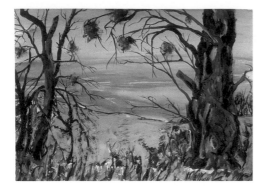

Bob Freimark

539A Dougherty Ave., Morgan Hill, CA 95037
(408) 779-2052
Represented by George Kisker, 4222 North
Marshall Way, Scottsdale, AZ 85251
(602) 481-0155
Freimark has exhibited in most of the major
museums of the world such as MOMA, NY; British
Museum; Bibliotheque, Nationale, Paris; National
Gallery, Prague; LA Co. Museum; Boston
Museum of Fine Arts. He has had over 200 one
man shows in Institutes such as Toledo Museum
of Art; Mpls Mus; Des Moines Art Center; Joslyn
Center Fine Arts, Torrance and Stanford Univ.
Mistletoe Mt. Fremont California - A Landscape Series.
Watercolor, 22 x 30. Artist's collection.

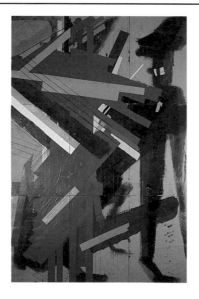

Stan Fylko

1567 40th St., Brooklyn, NY 11218

1983 I emigrated from Czechoslovakia. My
paintings are in the collections of these
museums:
Bratislava Museum - Slovakia
Prague Museum - Czechoslovakia
Budapest Museum - Hungary
Lodz Museum - Poland
Warsaw Museum - Poland
Folkwang Museum - West Germany
Lehmbruck Museum - West Germany
Guggenheim Museum - NYC
Niagara Museum University - NY

Spirit Shadow. Mixed media, 100 x 75. Artist's collection.

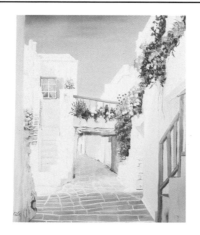

Gloria Lenakos Gaffney

2217 Hollister Ave., Scranton, PA 18508
(717) 346-6833

Represented by J & B Gallery, Scranton, PA
18508 (717) 344-4633

Gloria Lenakos Gaffney owns and operates
Gloria Art Studio in Scranton, PA. Master of Arts
degree from Univ of Illinois. Studied at Corcoran
School of Art, Wash. DC and Art Institute of
Chicago. Exhibited in Wash DC, Illinois, Florida,
Penn., New York, New Jersey, Maryland,
Michigan and Massachusetts.
Sun-Baked Isle, Hydra, Greece. Oil, 20 x 24. Private
collection.

Stephen Garner

Box 102, Elk, CA 95432

Fantasy and landscape/seascape watercolors; oil pastel and pencil from the model. 1987 - four works in "Contemporary Portraits 1", Grace Hudson Museum, Ukiah, California Also "Small works" and "All media" juried shows at Mendocino, California. Art Center. Have some commissions, both on-site and from photos. Experimenting with photo-panoramas and airbrush.

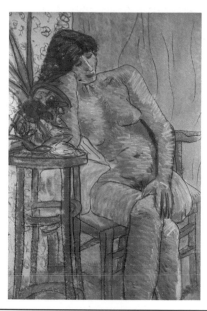

Untitled. Oil pastel, 16 x 22. Artist's collection.

Jean-Claude Gaugy

232 So. Federal Hwy, Boca Raton, FL 33432
(305) 338-5224

Represented by Gaugy Gallery, 232 So. Federal Hwy, Boca Raton, Fl 33432 (305) 338-5224

Born in France. Graduate, L'Ecole des Beaux Arts, Paris. Further study in Paris, Moscow, Rome and Oberammergau. In US since 1966. Lifetime professional artist. Sculpts and paints, but prefers the medium he has developed as uniquely his - paintings first carved into wood and then completed as oil paintings. Sizes from 18" x 20" to 60 foot murals.

Madonna. Carved, oil, 24 x 30. Artist's collection.

Jeremy Gilbert

530 Archibald Ct., Colton, CA 92324 (714) 825-7648

Jeremy Gilbert at age 15 is already a multi-talented author and illustrator. His favorite subject matters are horror and rock and roll stars as seen here in his painting of Madonna.

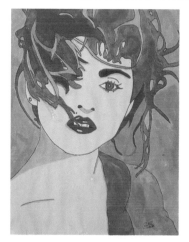

Madonna. Acrylic, ink, 11 x 14. Artist's collection.

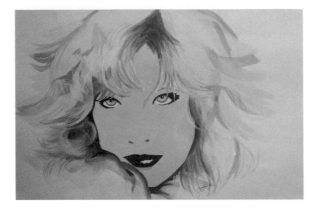

Jim Gilbert

530 Archibald Ct., PO Box 1543, Colton, CA 92324
(714) 825-7648

Once again working with his favorite subject, beautiful women, Jim has created Gloria, one of a set of portraits soon to be published. Note the eyes will follow you. Jim has been an artist for the past 20 years and is now publishing his work and is also accepting commission work.

Gloria. Acrylic, 18 x 24. Artist's collection.

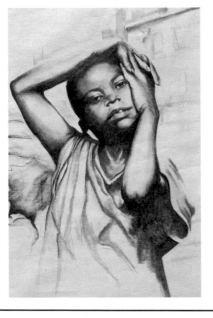

Jan Spivey Gilchrist

304 Ingleside, Glenwood, IL 60425 (312) 758-5310

Represented by Evanston Coop Gallery, 2603, Sheridan Road, Evanston, IL 60202 (312) 475-5310

Native Chicagoan. Resides in Glenwood, IL BS Eastern IL University, MA University Northern Iowa. Former teacher Phi Delta Kappa, Who's Who in The Midwest and numerous other awards and commissions. Presently painting as a fine artist and an illustrator of children's books for Putnam Publishing in NYC. I accept portrait commissions on request.

Boy of Boston. Graphite, 22 x 28. Artist's collection.

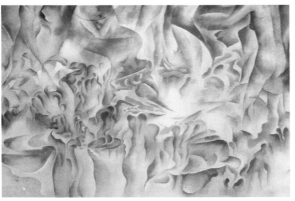

Sandipa Griffin

PO Box 37, Essex, MA 01929 (617) 281-5373

Represented by One Sky Design, PO Box 37, Essex MA 01929 (617) 281-5373

Sandipa has travelled extensively worldwide in Indonesia, Malaysia, Thailand, India, Greece and European Countries. She has tasted colors and cultures, and works in mediums of watercolor and acrylic. Has exhibited in Australia and California. Her present style attempts to express the deepest movement of the human spirit. Currently a freelance artist on Boston's North Shore.

Secret Place. Watercolor, 22 x 36. Artist's collection.

Marilyn Gross

54 Sunset Drive, Streator, IL 61364

Represented by Prism Gallery, 620 Davis St., Evanston, IL 60201

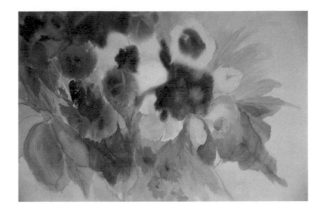

Impressionistic style of her work invites viewer to explore the beauty & mystery of our world and the inner workings of mind and spirit. Rich in color, her palette expresses a variety of moods from bold and dramatic to subtle & sensitive. Works included in numerous private and corporate collections throughout the US. Recognized by many awards and solo exhibitions.

Impressions. Watercolor, 22 x 29. Artist's collection.

Bruce James Habowski Jr.

9910 Lancewood St., Orlando, FL 32817
(305) 657-8695

Self- taught artist who has won awards in the 1982 and 1984 Congressional Arts Competitions, the 1983, 1984 Scholastic Art Competitions Merit Award, Laitland Arts Festival 1982 and numerous other awards.

At the Beach. Colored pencil, 18 x 24. Artists Collection.

Helle Hane

PO Box 286, Solvang, CA 93463 (805) 688-1684

Palletten Gallery, 433 Alisal Rd, PO Box 1520, Solvang, CA 93463 (805) 688-7999

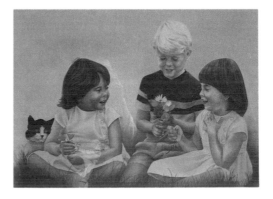

Helle Hane is a respected rising artist whose sensitive portraits of people are bringing her acclaim. Helle captures the feelings and expression in each subject, and she especially loves painting children in their natural surroundings. Private collectors include President and Mrs. Nancy Reagan, The Prince and Princess of Wales and John Denver.

Springtime Fascination. Watercolor, 20 x 30. Private collection.

Daniel Hanequand

504 Washington St., #2, Peeksill, NY 10566

Born in Paris, France. Raised and educated in Paris. Drawing, Painting. 3rd International Exhibition of Graphic Art, Frechen, Germany 1974. Joan Miro International drawing competition Barcelona, Spain 1972, 73, 74, 75. Miniature awards winner, Oakland Museum, California. Achenbach Foundation for graphic art San Francisco, CA. Victoria and Albert Museum, London, England. US resident.

Dead End. Oil, 8 x 10. Artist's collection.

Neva Hansen

87 Division Street, Saratoga Springs, NY 12866
(518) 584-3726

Represented by Ariel Gallery, 76 Greene St., NY, NY 10012 (212) 226-8176

Early training; children's classes at the Cleveland Museum of Art. BFA 1958 Rochester Institute of Technology: MFA, 1963 University of Pennsylvania. Saratoga Springs resident since 1972. Interests; Haiku, Norse Myths, gardening, trips to the seashore and kites. Seashells, plant and insect forms together with metaphysical ideas are important elements in work.

The Long Serpent. Oil, 53 x 36 x 7. Artist's collection.

William Harroff

138 East Fifth, Roxana, IL 62084 (618) 251-4477

William Harroff, a native of Northern Indiana, is a book artist. His work combines visual imagery and the written word to produce artists books, illustrated prose and children's books. He has degrees from Purdue and Indiana University. The artist has taught illustration at O. Kokoschka's School of Vision in Austria. He exhibits throughout the United States.

Gulliver's Travels . (Detail). In artist's books, 26 x 40. Artist's collection.

Stuart Harwood

5901 Pescadero Rd, Pescadero, CA 94060

5 major sculptures public collections Includes Whitney. Dozens in private collections. 30 shows SF - NY. Awards: Fulbright '56, Sumner Foundation '62. 3rd Prize Sculpture '87 Johnson Atelier NJ. Best of Show San Jose Ar League '87. Apprentice to Jose de Creeft, Stone; Bronze with Aldo Vignali, Firenze, wood with Micronesian carvers. Assemblage of found objects, leather, paper feather, foil fiber, plastic, etc.

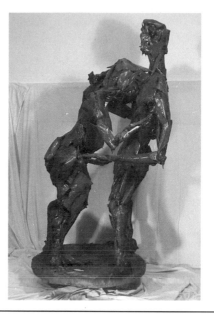

Closed Relationship. Leather, Red, 3 x 3 x 7. Photo by A. Russel Lee. Artist's collection.

Lynn Hassan

253 Railroad Box 645, Woodacre, CA 94973
(415) 488-0474

From dream world to waking world, sifting, sorting, questioning, coming to know through shapes, colors, dark and light. Paint helps me find a place in this universe, giving me a voice to share my vision. I studied at Art Center, California Institute of Art and Otis Art Institute.

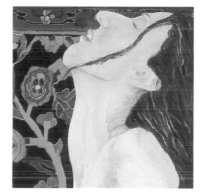

Amy II. Oil, 11 x 11. Artist's collection.

Sherman Hay

PO Box 5211, Sonora, CA 95370 (209) 533-4832

Born in San Jose California in 1948, Sherman spent his early years backpacking in remote areas of California. These interactions with nature are manifested in Sherman's art. His work focuses on constructing mini environmental installations. Mr. Hay feels it is important to bring the consciousness of art up to the level of modern scientific innovations.

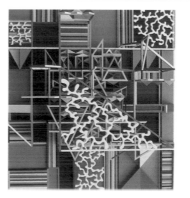

Shrine for the Absurd. Painted wood, 22 x 24 x 12. Artist's collection.

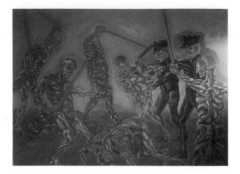

Roger Hayes

22476 Barbara, Detroit, MI 48223

Represented by Sheldon Ross Gallery, 250 Martin St., Birmingham, MI 48011

Solo show at Race St. Gallery, Grand Rapids, Michigan in Oct. '85. Three person show "Hayes, Lucas, Owens" at Spaces, Cleveland, Ohio in Sept '86. Recipient of 1986-87 individual artist grant from the Michigan Council for the arts. Solo show at Sheldon Ross Gallery, Birmingham, Michigan April - May '87.

Riot. Oil, 90 x 17. Artist's collection.

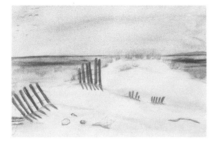

Katie M. Helms

469 Clontz Long Rd, Monroe, NC 28110

Artist and writer. Does landscapes and portraits in watercolor, oils and other media. Author of one art book.

Summer. Watercolor, 21 1/2 x 14 1/2. Artist's collection

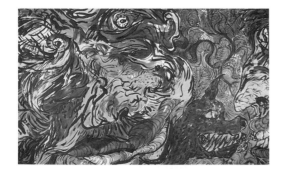

John Himmelfarb

163 N Humphrey, Oak Park, IL 60302

Represented by Terry Dintenfass, 50 W 57th St., New York, NY 10019

Museum collections; Art Institute of Chicago; Brooklyn Museum; Cleveland Museum; Fogg Art Museum; High Museum; Minneapolis Institute of Art; National Museum of American Art; Portland Art Museum; Rose Art Museum; Baltimore Art Museum. Solo Shows: Dintenfass 79, 83, 86. John Nichols, NYC 86; Areax NYC 85.; Davenport Art Museum 86; Brodys, DC 85; Gallery 72 Omaha 85, 83, 79.; NEA 85, 82.

Giants' Meeting . Brush and ink, 90 x 144. Private collection.

John Thurston Hincks

6949 Sayre Dr., Oakland, CA 94611

My art involvement began with the social experiments of the 60's. I liked working in acrylics. In the 70's it was oils. Now though, I still use oils. I've included audio with video and computer paint programs to transform what was just a pictoral idea to an actual event. Thus I can extend a sense of being real while enhancing it's abstractions.

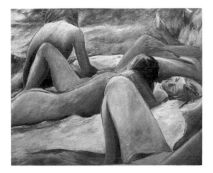

The 60's. Oil, 48 x 37. Artist's collection.

Michael Hopkins

302 N. Pine Ave #3W, Arlington Heights, IL 60004

Born in Illinois. Attended W.R. Harper College, American Academy of Art and The Art Institute of Chicago from which I got my BFA. Monoprints at Van Straaten Gallery in Chicago. Currently teaching at W.R. Harper College and schools in the suburbs.

Untitled. Pastel, 4.2 x 9.8. Artist's collection.

Diane Hoppmann

40 Westwood Circle, Irvington, NY 10533

Born in Madison, Wisconisn. Raised in Chicago. Living in New York. Northern Virginia College, AS; Corcoran School of Art, BFA; School of Art Institute of Chicago.

Fire and Earth. Oil, 84 x 54. Private collection.

Joe Hurwitz

10204 Kindly Court, Gaithersburg, MD 20879

Represented by Venable-Neslage, 1803 Connecticut Ave., NW, Washington, DC 20009

BA, University of Illinois, Champaign-Urbana; MA and MFA, University of Iowa, Iowa City. Taught anatomy, drawing, and sculpture, two years Eastern KY University, Richmond. Recent shows, awards: Hoyt National Drawing and Painting Show, 1986, Drawing, New Castle, PA; 1st prize, Montgomery Cnty. Juried art exhibit 1986, sculpture, Rockville, MD, Foundry in Damascus, MD.

Bust of Old Man. Bronze, 19 x 14.

R. R. Iaccarino

115 McClellan Boulevard, Davenport, IA 52803
(319) 359-5522

Independent artist. Selected exhibits: Ruth Volid Gallery Ltd., Chicago, 1986; Watercolor USA - The Monumental Image, Springfield Art Museum, Springfield, MO, 1986; 1986 Mid-America Biennial, Owensboro Museum of Fine Art, KY, 1986. Collections of: Northwestern Bell Telephone, Des Moines, Iowa; University of Minnesota Hospitals; Hyatt Hotels. 17 solo exhibitions.

Twilight in the French Drawing Room. Watercolor, 22 x 30. Artist's collection.

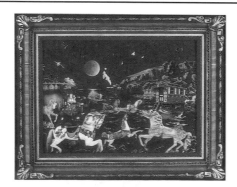

Gary Imsdahl

549 Fawcett, Grass Valley, CA 95945
(916) 272-8924

Represented by Dori-Lisa Saunders, 549 Fawcett, Grass Valley, CA 95945 (916) 272-8924

Award winner 1986 International Art Competition, NYC. Shows: San Francisco, Sacramento, Nevada and Marin Counties, CA. Sales: Bi-coastal USA. Works exclusively with collage. May use over one hundred photo images unifying them with acrylics. Antique frames are personally restored and designed. Refers to work as "Dreamscapes".

Carnival. Collage, 21 x 25. Artist's collection.

Elena Laza Itsu

204 Dodd Street, Weehawken, NJ 07087

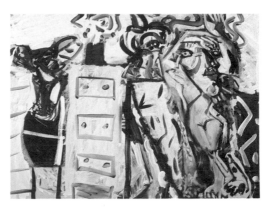

Received BFA in Oradea Romania and MFA from
N. Grigorescu Academy of Fine Arts, Bucharest,
1974. From 1981 exhibited in USA paintings and
prints, winning awards. Works in handmade
books at "Vital Signs' limited edtions using fine
printmaking techniques. Recent paintings
received Ruth Chenven Foundation Grant 1986.
Image referre synthetic realism.

Interior. Acrylic, 40 x 30. Artist's collection.

Steve Jensen

2929 Mayfair Ave N, Seattle, WA 98109
(206) 282-1204

Represented by Foster/White Gallery, 311 1/2
Occidental Ave S, Seattle, WA 98104

Pacific Winds is a piece from a series entitled NW
Waterways. The images are based on an
interpretation of the physical nature of water, its
continual movement, curvatures and flowing
qualities. The shapes are likened to calligraphy
strokes caught in midair and frozen in time and
space in cast bronze or aluminum.

Pacific Winds, from the NW Waterways Series. Aluminum,
120 x 60. Artist's collection.

Peter Johannes

Ravenwood Studios Box 212, Robbinston, ME
04671

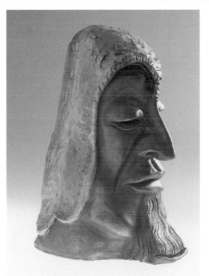

Studies include: Van Gogh Museum,
Amsterdam; Volks University of Amsterdam;
Haystack Mountain School of Crafts; Longboat
Key Art Center, Florida. Johannes works in
bronze, steel, wood, clay and precious metal.
Also works in the graphic arts: lithography, lino
cut and monotypo. His work is displayod in
private collections across the country, Africa and
Europe.

Ancient Sentinel. Raku, 12 x 8 x 7. Artist's collection.

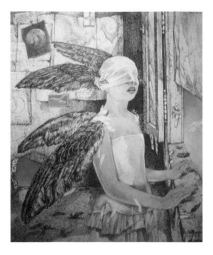

Anna B. Jurinich

33-32 155 Street, Flushing, NY 11354

Represented by Marie Pellicone Gallery, 47 Bond St, NY NY 10012

Attended on scholarship Parsons School of Design, NY. Studied and lived in Florence, Italy for 3 years. Illustrated magazine articles and 2 book jackets for Knopf Publishers, one of which was awarded by the American Institute of Graphic Arts. Numerous group shows in Manhattan and Southampton, NY. First solo exhibition April 1986, at Marie Pellicone Gallery, NY.

Courageous Journey. Acrylic, ink, 14 x 7. Private collection.

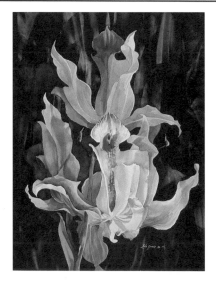

Lola Juris

3200 Buena Hills Dr., Oceanside, CA 92056
(619) 439-9999

Represented by Stanhope Gallery and Lapis Moon Gallery, San Diego, CA 92103

Parsons School of Design, BFA; Syracuse U., MFA. Also attended Boston U., Mass. College Art, Cal. College Arts & Crafts. Taught at 2 colleges in Boston. Presently at 2 in Calif. Seven solo and many group shows. In private and corporate collections in NYC, Boston, Germany, Israel. Subtle lyracism expressed through natural, organic forms in watercolor.

Alizarin Anthem. Watercolor, 21 x 28. Artist's collection.

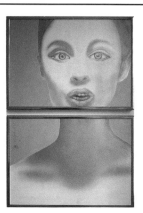

Mark Kadota

PO Box 2384, Waianae, HI 96792

Mark Kadota has shown through the Fine Arts Museum of San Francisco and the De Young Museum Art School in California, , the Bishop Museum, the Honolulu Academy of Arts and the Contemporary Arts Center in Hawaii. Other shows include museum Het Toreke in Belgium and a commission by the City of Honolulu for a piece in the Waianae City Hall.

Yes...Koreen. Inks and dyes, 22 x 34.

Kathy Walden Kaplan

11223 Leatherwood Drive, Reston, VA 22091
(703) 476-0516

Kathy Kaplan is a sculptor/lithographer. She does relief sculpture, stone lithography and handmade books. One person shows in Fez, Morocco, Alexandria and Reston, VA, Washington, DC and Ventura, CA. Memberf of the Los Angeles Printmaking Society and prints at the Torpedo Factory Art Center in Alexandria, VA.

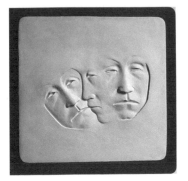

Susan Rachael. Cast stone, 11 x 11. Artist's collection.

Wendy Kaplowitz

1838 East 12th St., Brooklyn, NY 11229

Professional artist with broad spectrum of experience in : freelance fashion illustration, commercial art, art education and computer graphics. After many years of studying the traditional type of art, I have chosen the newest media, state of the art technology computer animation. This is applied to television. I am only an artist who operates a computer.

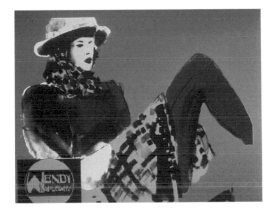

Orange Lady. Computer graphic.

Ellen Kessberger

1595 Pacific Avenue, Alameda, CA 94501

Represented by Editions Limited West Gallery, 1 Market Plaza, SF, CA 94105 and Barlett Gallery, West Neal St., Pleasanton, CA 94566

Handbuilt porcelain and ceramic sculptures are inspired by a variety of floral, plant and undersea life found in the San Francisco Bay Area. The rhythmic, flowing shapes are suggestive of the dynamic lifeforms found within California's natural environment. Soft, subtle, smooth surfaces and thin, delicate shapes give my works a light, buoyant, sensuous quality.

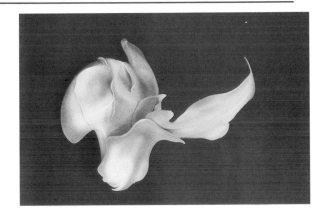

Aquatic Life. Ceramic, 14 x 14 x 15. Artist's collection.

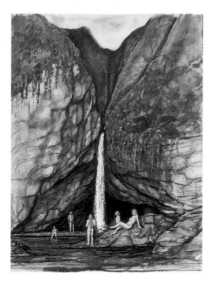

Jeff Kimerer

Box 1169, Haleiwa, HI 96712

Represented by Association of Hawaii Artists, Box 102020, Honolulu, HI 96816

This is a painting of an encounter. In the act I'm always trying to imagine the future. Not 2001 or even next week but moment to moment. I am glad for limits. Without limits my imagination may lead to catastrophe! I can use line, shape and tone to create form and orient myself to this experience.

Water Nymphs. Watercolor, 11 x 15. Artist's collection.

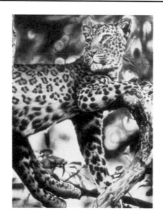

Harlan Bayard King

Rte. 3 Box 342, Broken Bow, OK 74728

Self taught artist who does portraits, landscapes and animals in pencil, pastel, watercolor and oil. He also does pictures in ink dots. Shalane McCall and Priscilla Presley are among his clients.

Lazy Leopard. Pencil, 18 x 24. Artist's collection.

Nancy Kittredge

c/o Joy Horwich Gallery, 226 East Ontario, Chicago, IL 60601 (312) 787-0171

Nancy Kittredge's oil paintings are charged with expressionistic intensity in both concept and color. Her work deals with psychological alternate realities, the result of which brings power and mystery to her figures.

The Calling. Oil, 60 x 96.

Diana Kleidon

20 Brookside Place, Springfield, IL 62704
(217) 787-3022

The Prism Gallery, 620 Davis Street, Evanston, IL
60201 (312) 475-7500

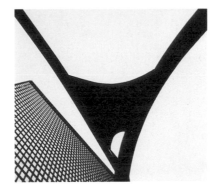

Ms. Kleidon has exhibited her work nationally for
nine years, including a 10 year retrospective in
1985. She has received national awards for her
photography, and her work is in the private and
public collection. Kleidon is presently working on
her first book of photographs which will be
published sometime in 1987.

Untitled (Calder). Photography, 20 x 16. Artist's collection.

Pete Knowlton

PO Box 6233, Rochester, MN 55903

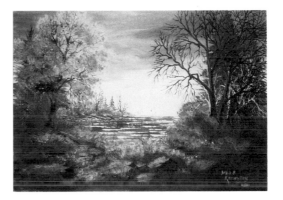

Having worked in all mediums, I prefer acrylics for
versatility. Have designed menu covers and
engravings for china cups and collector plates.
Have sold to many private collectors and
galleries both at home and abroad. Being a
native Minnesotan, my first love has always been
landscapes, with natures every changing colors.

Autumn on Lake Superior. Acrylic, 18 x 24. Artist's collection.

GG Kopilak

2 Hickman Street, Syosset, New York 11791

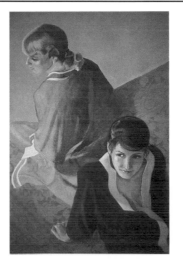

Portrait, figure and still life artists working with oils
and pastels. Born in New York City. Exhibitions
include galleries and museums in New York City
and Metropolitan Area. Presently showing at
Gallery III, Sayville, NY. Numerous awards.
Collectorstors include Nassau Community
College. Reviews in New York Times and
Newsday.

Complements. Paste, 32 x 48.

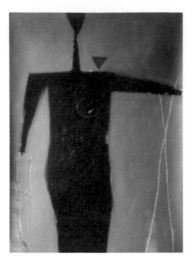

Maggie Kornman

66 Hamilton Place, Oakland, CA 94612

I am interested in suggestions, edges, spaces and colors in between. That which appears to be truth (physical) and that which we know to be true (spirit). Artmaking/ritual are links between inner and outer worlds.

Able Woman 32. Oil, 45 x 33. Artist's collection.

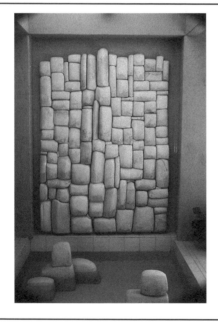

Gail Kristensen

106 Vista Bonita, Sedona, AZ 86336

Represented by Elaine Horwitch Gallery, Highway 179, Sedona, AZ 86336

Guest American Artist, Weisbadden, Germany. Prof. of Art, Macalester College, St. Paul, Minnesota. Title member International Academy of Ceramics Commission.Works throughout the Midwest and Southwest "I am interested in bridging the sterility of modernism and the freedom of nature". Creativity in harmony with master craftsmanship.

Wall and Pool Sculpture. Ceramic stoneware, 6' x 8'. Private collection.

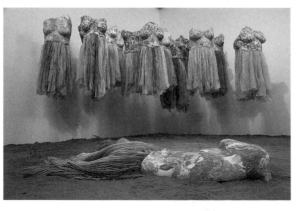

Deborah Kruger

Brickyard Hollow, Montague, MA 01351
(413) 863-9402

Represented by Ceres Gallery, 91 Franklin ST., NY NY 109013 (212) 226-4725

Deborah Kruger was born in New York City and studied textile design at FIT. She has exhibited and lectured throughout the US. Kruger's sculptural installation work integrates feminism, politics, and spirituality.

Tribe of Dina. Mixed media, 5' x 9' x 8'. Artist's collection.

Nancy Kubal

3328 Bent Twig Lane, Diamond Bar, CA 91765

Born in Lowell, Massachusetts, studied in Kyoto, Japan for Fine Arts . Studied commercial arts in Los Angeles at Los Angeles Trade Technical College. I am currently a freelance oil portrait artists based in Los Angeles. I am a member of The Bevery Hills Art League. Galleries where my works have been shown: Eva Dorog Gallery, Soho Gallery.

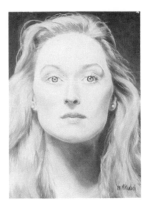

Mery l Streep. Oil, 26 x 38.

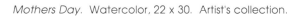

Mary LaGreca

153 Hilburn Road, Scarsdale, NY 10583
(914) 723-2356

Represented by The Village Art Gallery, 7 Pondfield Rd, Bronxville, NY 10708 (914) 337 7711

Director-instructor Village Art Gallery Bronxville, NY.College: New Rochelle, NY; private instruction internationally. Known watercolorists exhibited Hudson Valley. Juried Cork Gallery, Avery Fisher Hall NYC. Recipient award of excellence, Federal Plaza NYC. Best in show floral paintings Stamford Art Gallery. Member Salmagundi Club, American Artists Prof essional League, NY.

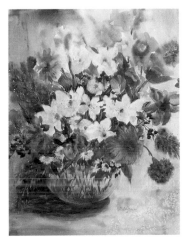

Mothers Day. Watercolor, 22 x 30. Artist's collection.

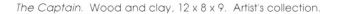

Sherry Lane

155 Bank Street, New York , NY 10014

Represented by Westbeth Gallery, 57 Bethune, Studio 404, NY, NY 10014

Sherry Lane has been capturing the essence of people for 20 years. She is New York's most prominent caricature artist. She has drawn celebrities at Sardi's, traveled throughout the country for Time Magazine and around the world for Pan Am World Airways. Her caricatures were published weekly in Star Magazine from 1983 to 1986. Also, she does portraits in clay.

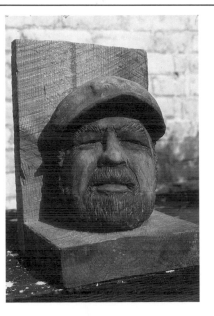

The Captain. Wood and clay, 12 x 8 x 9. Artist's collection.

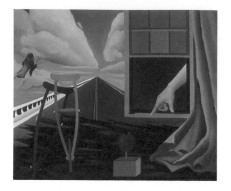

Anna Lascari

83-85 Mac Dougal St., New York City, NY 10012

Athens born artist, Anna Lascari, earned her Bachelor of Arts Degree in Painting from the Athens School of Fine Arts in Greece. She did graduate work in New York City at Pratt Institute where she majored in painting and minored in print making, earning a masters of Fine Arts degree in 1981.

Crutch Race. Oil, 44 x 52. Artist's collection.

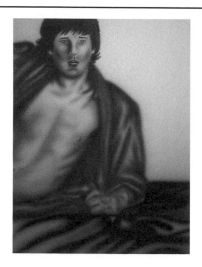

Donna Yvonne Lee

Box 323, APO MI 34004

Attended Cooper School of Art in Cleveland, Ohio. Is a member of the National League of American Penwomen and Associated Photographers International. Freelance photojournalist for news periodical in US and Latin American countries. Currently working on a black and white photo essay on French Colonial Panama.

Paseo de Las Bovedas. Photograph, 16 x 20. Artist's collection.

Ana Leon

4391 Washington St., Apt. 2, Roslindale, MA 02131

Represented by Galeria Botello, Plaza Las Americas 143, Hato Rey, Puerto Rico 00918

Born Cuba. BA Fine Arts 1976, Escuela Artes Plasticas, ICP, Puerto Rico. Shows: MFA, Boston Mocha, NY; Museo Bellas Artes, Puerto Rico; Federal Reserve Bank, Bos; Foundry Gallery, Wash DC. Recipient of several awards. Listed Who's Who in American Art, The World Who's Who of Women and Contemporary Airbrushing in America.

Nostalgia. Acrylic. 24 x 18. Artist's collection.

Lawrence D. Leppo

12 Fulton St., Hanover, PA 17331

Represented by B. Plotica, 600 Long Rd, Gettysburg, PA 17325

Leppo has developed SOLAR SILHOUETTE SCULPTURE, a new and exciting art form that he has been producing since the 1970's. This sculpture is a modern form which, with application of light, casts a shadow that is a recognizable and predetermined artwork in its own right. Modern sculpture that is visually understandable is the goal of the artist.

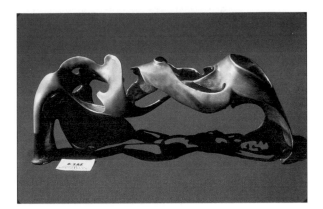

Reclining Nude. Bronze, 20 x 5 x 8. Artist's collection.

Reva Beth Levy

3051 Edwin Avenue, Apt. 4F, Fort Lee, NJ 07024

I am an artist who specializes in large posters of people, landscapes, stilllife and popart. I use both watercolor and designer gouche.

The Sheik. Watercolor, 14 x 20.

Leslie Lew

24 E 20th St., New York, NY 10003

Represented by Bernice Steinbuam, 132 Greene St., New York, NY 10012

Born in New York City. Ms. Lew got her BFA and MFA at the Art Institute of Chicago. She is known for building out her paintings with a pure oil paint. She has shown at the Museum of The Art Institute of Chicago, SVA Museum and Wilson Art Museum. Her newest work is on wood-paneled screens. She uses a wide range of symbolic images that relate to our lives.

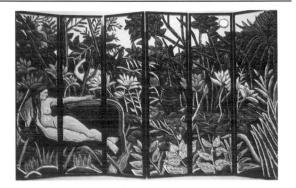

Ode to Rousseau. Oil, 60 x 17 x 102. Artist's collection.

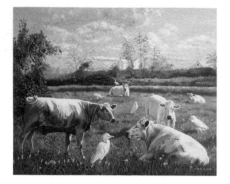

Beverly R. Lynch

Box 35 E, Newark, MD 21841　(301) 641-3450

Represented by South Point Gallery, Box 691, Ocean City, MD 21842 (301) 289-0140

Beverly is a self-taught landscape and animal painter. She was a professional decorative artist - murals, interiors, furniture - for 16 years and a full time fine artist since 1985. Limited edition prints available.

Charolais and Egrets. Acrylic, 20 x 24. Private collection.

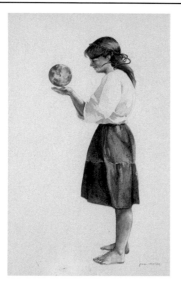

Jane A. Maday

1354 NE 31st Place, Gainesville, FL 32609

Attended Ringling School of Art and Design in Sarasota, FL. Jane Maday is a fine artist and illustrator specializing in children's books. As a fine artist she has received much recognition for her brightly colored watercolors, and has exhibited in several galleries and shows across Florida. Her work is currently available through the Sun Center Gallery in Gainesville, FL.

She's Got the Whole World in Her Hands. Watercolor, 14 x 20. Artist's collection.

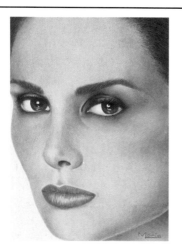

Maria Maddlone

210 No. Catalina St., Los Angeles, CA 90004

Born in Cuba; raised in Los Angeles, California. Studied graphics design and illustration at Otis/ Parsons School of Design. Presently owner and founder of "The Professional Edge" in Los Angeles. Currently seeking gallery representation.

Untitled. Pencil, 9 x 12. Artist's collection.

Fabian Marcaccio

541 18th St., Brooklyn, NY 11215

Studies at Rosario Univ. Argentina. Numerous shows and awards. Exxon Scholarship. Shown in group exhibitions on east and west coasts - LA Muerte, San Antonio, Texas. New York National Bank award ; Americanos Lincoln Center, NY; Arthur Ross Gallery, Philadelphia ; Art Action, NJ Museum. Works in acrylic, oil, as well as several graphic mediums.

The Antagonist. Acrylic, 148 x 74. Artist's collection.

Anne Mulder Maurice

122 Sandpiper Circle, Corte Madera, CA 94925
(415) 924-8305

Anne has been working and teaching in the field of ceramics for the past fourteen years. She holds an MFA and a BFA in Ceramics. Her work has been shown locally, nationally and internationally. Current works shown are Oriental style Kite-Sails. The artists intention is to "Capture a frozen moment in flight caught between the traditional past and contemporary present."

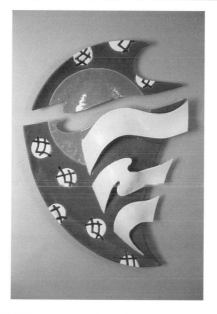

Wing of the Wind (Wall Piece). Clay, glazes, 25 x 24 x 4.

John E McAlpin

3822 Murray Court, Fort Worth TX 76107

Represented by Oak Street Gallery, 208 West Oak Street, Denton, TX 76201

Education: Master of Fine Arts Degree, North Texas State University, 1986; Bachelor of Fine Arts, NTSU, 1981. Has shown in Texas, Tennessee, Colorado, and North Dakota. Does prints which symbolically depict cerebral activity. Belongs to the Dallas Chapter of the Women's Caucus for Art. Has been published (photo) and is in the permanent collection at North Texas State University.

Mind's Eye; Bull's Eye. Printmaking, 34 x 23. Artist's collection.

John Mc Cormack

307 East 76 Street, Apt #13, New York, NY 10021
(212) 628-9490

Brooklyn Museum Art School; Accademia Di
Belle Arti De Rome, Rome, Italy; Art Student
League, NY. Exhibitions: 55 Mercer Street Gallery,
Peter Miller Gallery, Metropolitan Museum of Art,
Brooklyn Museum, Public Image Red Show,
Plexus Opening Show, Art Student League,
Publications: 1984, the Go See Syndrome,
Artspeak, NY.

Day. Oil, 36 x 24

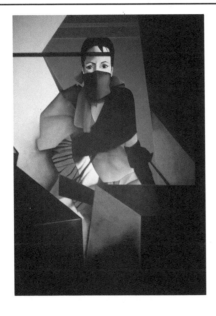

Sandra McKee

106 Ridge St., New York, NY 10002

Studied at Parsons School of Design, NYC. Has
exhibited recently at museums in Tokyo,
Stockholm, Barcelona, Sao Paulo, the Hague
and Los Angeles, as well as downtown NYC
galleries and clubs. Taught at University of
Oregon and won Gulf- Western Art Residency
to Altos de Chavon, Dominican Republic in 1983.

Hi, Jack. Oil, 48 x 60. Artist's collection.

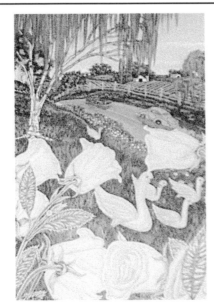

Willie D. McNeil

PO Box 187, 1550 Dayton St., Aurora, Co 80040
(303) 340-4543

Painted an entire lifetime. Active commission
work 29 years. Two years training, Art Instruction
School, Minneapolis, Minnesota 1954. One year
Denver Art Academy 1957. Exhibits: Colorado
State Fair, Palmer Lake Art Group Show and
Denver Art Museum. 40 works sold 20 years. Do
works from photos, image, nature.

Country Traffic of Five Ducks and Flowers. Oils, 18 x 24.
Artist's collection.

Grace Merjanian

18701 Deodar St., Fountain Valley, CA 92708

Represented by Mariners Art Gallery, 34505 Street
of Golden Lantern, Dana Point, CA 92629

Has won over fifty awards for her oil and
watercolor paintings. She was artist of the year in
1983 and 1984. Her paintings are in collections
throughout the US., Canada, Lebanon, Germany
and So. Africa. Her works are exhibited at
Mariners, Forbes, Costa Mesa Art, and Art - A- Fair
Galleries. July and August each year she shows at
the Laguna Art - A - Fair festival.

Country Memories. Watercolor with gouache, 15 x 19. Prints
available. Artist's collection.

Nancy Rose Anne Middendorf

4934 Brock Street, Apt. 102, Indianapolis, IN 46254

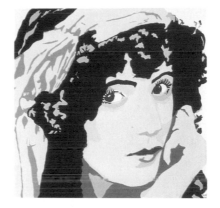

I enjoy being able to experiment with
alternatives. When given the challenge of
creating a silkscreened portrait, without the
expense and time involvement usually
associated with producing one finished piece of
silkscreened art, I relied upon my acrylic paints to
create the look of a silkscreened image. The
end result? Fabulous! and much easier to
produce, too.

Gypsy. Acrylics, 18 x 24. Artist's collection.

Corinne Howard Mitchell

500 Missouri Ave., NW, Washington, DC 20011

Represented by Sun Gallery, 2324 18th Street,
Washington, DC 20001

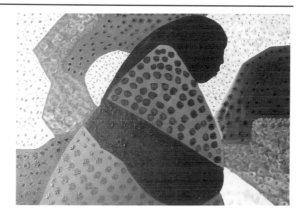

Retired art teacher. Traveled and studied in
Africa, Europe and Asia. Over one hundred
group shows and ten solo exhibitions. Corinne
says" I feel a great need for the production of
what I consider beautiful. This beauty I speak of is
often expressed in my landscapes, abstract or
figure paintings."

Tizzy. Acrylic, 30 x 40. Artist's collection.

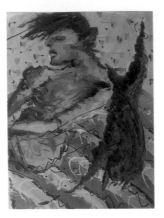

Linda Mitchell

1580 Loring Drive, Atlanta, GA 30309
(404) 876-5304

Bachelor of Fine Arts in Drawing and painting, University of Georgia. Exhibitions in various juried shows, businesses and galleries form 1979 to 1987. My work is a constant exploration of color and form with an emotional bent.

Circus. Acrylic, 40 x 30. Artist's collection.

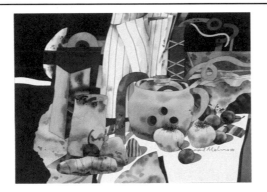

Carl N. Molno

60-11 Broadway, Woodside, NY 11377

Painter, illustrator, art teacher working in both an abstract and representational manner. Recipient of many awards. Has participated in several solo and group shows in various New York City area galleries.

Garlic Pot. Watercolor, 9 x 12.

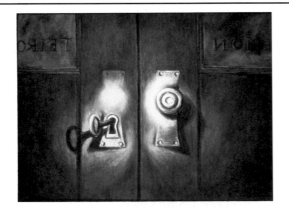

Isaac Monteiro

39 Raynor Street, Greenport, NY 11520

Represented by Leon Boyar, PO Box 1511, Wall Street Station, NY, NY 10268

Born in Antwerp, Belgium, 1938. Studied art in Rio De Janeiro and in Europe. Since 1965 lives and works in New York. In 1971 became a US citizen. Exhibitions in Rio, Paris, Amsterdam, Madrid, Tel-Aviv, Milan, New York, Bern, Munich, Los Angeles, and Rome. Works in private and public collections in the USA, Europe, and America.

Determination. Oil, 24 x 18. Private collection.

Angela Morett

15811 Quartz Street, Westminster, CA 92683
(714) 894-5204

Angela Morett was born and raised in California and graduated form California State University, Long Beach, with a degree in art. Angela has recently become competitive on a national basis and is presently a freelance illustrator and designer in the Southern California area.

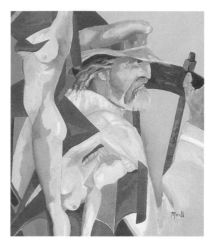

Forgotten Dream. Oil, 30 x 28. Private collection.

William Nelson

100 W. Kenilworth Dr., Prospect Heights, IL 60070

School of Art Institute, Chicago. Although painting style is realistic, ordinary images and mystical themes are sometimes used as symbolic gestures in an attempt to spiritually portray contemporary life. William Nelson's work has been exhibited recently in NY and the Chicago Art Institute. His work is included in many permanent collections and museums in the US.

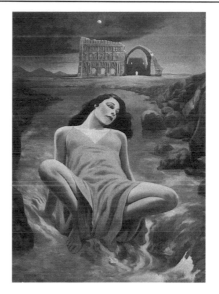

Antiquity and Myth. Oil, 56 x 40. Artist's collection.

Melody Newell

3263 Esterbrook Road, Douglas, WY 82633

Represented by Pine Tree Gallery, 114 Pine Street, Troy, AL 36081

Melody Newell likes to portray her subjects (from people to wildlife and landscapes) in a realist style. Born and raised in Wyoming and resides in her mountain home hear Laramie Peak. Likes to paint subjects that stir feelings or recollections or give a feeling of peace. At this point in her career she finds people with character a fascinating challenge.

The Hairdresser. Watercolor, 12 x 16. Artist's collection.

Kosol Nimnual

87 Thorne Street, Jersey City, NJ 07307
(201) 798-0454

The Thai artist Kosol Nimnual had many honors which he brought from Bangkok to New York at age of 24. He received a Master of Fine Arts from Pratt Institute 4 years later. His paintings are based on strong illusion and contradictions of that illusion. Light directions change, colors mutate and expectations are altered as the wrinkles creating a body of work.

Untitled # 3184. Acrylic, 20 1/2 x 28 1/2. Artist's collection.

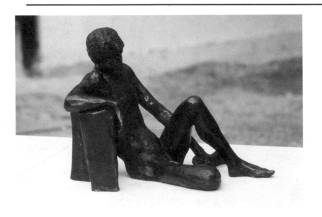

Donald Claude Noel

1406 Main Street, Green Bay, WI 54302
(414) 433-0450
Represented by Open Sea Sculpture Studio, 1406 Main Street, Green Bay, WI 54302

MFA in sculpture from Villa Schifanoia, Florence, Italy, 1983. Studies in Chicago, Philadelphia, Mexico. Worked in Yugoslavia, Pietrasanta-Carrara. Exhibits: Florence, Pietrasanta, Chicago. Own Green Bay Gallery. Primarily figurative but also abstract, architectural: Bronze, marble, terra cotta, etc. Mosaics in marble and glass. Current commissions to $90,000.
Tolle, Lege (Tommasi Foundry Pietrasanta, Italy). Bronze, 12 x 18 x 12. Private collection.

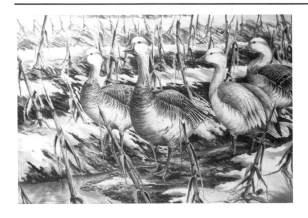

John Obolewicz

2818 Rocky Oak Road, Powhatan, VA 23139

Wildlife and landscape artist. Praised for his knowledgeable studies of subject matter and sensitivity, a breath of life in his wildlife. Graduate of NY State College at New Paltz, a BFA in painting and a minor in ornithology. Active in professional exhibiting, commission painting, art societies, receiving many awards and first prizes for outstanding works.

Cornfield. Watercolor, 20 x 27 1/2.

Donald O'Keefe

1267 B 7th Ave., Santa Cruz, CA 95062
(408) 476-5871

I was born in San Francisco, California. Early on I was attracted to drawing, shape and color - but was told that this was not something to be pursued by a 50's male. I believed then...but stopped 'believing' about three years ago. Today I am a painter - expressing myself through oil paint. Constantly experimenting with line, shape, color and texture.

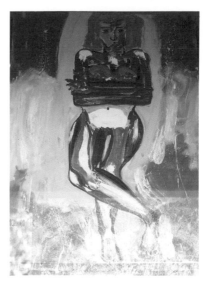

Argyle Woman. Oil, 30 x 40. Artist's collection.

Lynn Olson

4607 Claussen Lane, Valparaiso, IN 46383
(219) 464-1792

I sculpt directly in cement. I have developed techniques that make cement a direct modeling medium without molds. Reinforced with steel, these designs can be of any size or complexity and from the textured to smooth and polished. They include stained slab glass designs mounted in ferro-cement. These techniques are explained in my book, Sculpting With Cement.

Franciscan Sister. Cement - Steel, 51 x 18 x 18. Private collection.

Jose Luis Ortiz

312 East 93rd St., New York, NY 10128

Born in Mexico City. His style is figurative, narrative, primitive, psychological and representative. My media are paint, prints, collage, mixed media, installations and 3D. The materials are oil, acrylic, canvas, metal, wood, paper and papermaking. The scale is medium, large and architectural for outdoors. Mr. Ortiz has exhibited his work in Mexico, USA, Canada and Latin America.

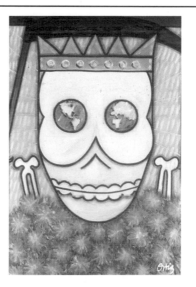

Cempasuchil for the World. Acrylic, 50 x 38. Artist's collection.

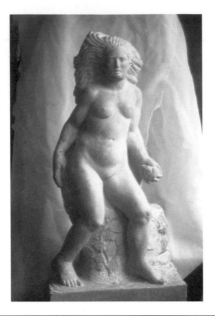

Fleur Palau

218 East 6th St., New York, NY 10003 (212) 260-3702

Fleurs work in clay, bronze and stone marks the beginning of a new humanism - a redefinition of ourselves in this century. With these raw materials, she translates her ideas into images of monumnetal scale and power. A them she is developing is one of heroic feminism. Her work is exhibited in USA and Italy where she lives and works part of the year.

Woman. Bardillio marble, 36 x 30 x 24. Artist's collection.

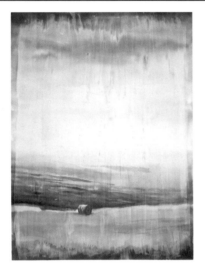

William L. Parker III

Route 1 Box 154A, Parkerville, KS 66872
(913) 349-5561

Represented by Union Hill Arts, 3013 Main, Kansas City, MO 64108 (816) 561-3020

If one word describes my work it is EMOTION: EMOTION displayed in COLOR and LINE, and honed by need - If you are emotional let my work tell you my feelings. For five years Union Hill Arts Gallery has shown and represented my work in Kansas City, MO. I am also shown and represented by Ariel Gallery, 76 Greene St., Soho, NY. 10012 (212) 226-8176.`

Haybale Study #3. Mix media, 22 x 30.

William Andrew Pence

121 Carnegie St., Butler, PA 16001 (412) 285-5581

Residing in Butler, Pennsylvania with his wife and 2 daughters, William Pence works from his home as a freelance artist. With 14 years of experience, his designs cover a wide range of subjects. He works in airbrush, pen and ink, and acrylics. His design experience includes posters used at the 1982 Worlds Fair, menu covers, retail ads, and many popular T-shirt designs.

Ice Creme Dream. Airbrush, 28 x 22. Artist's collection.

Marcus Andre Penido

140 55 Tahiti Way #107, Marina Del Rey, CA 90292

Born in New Jersey, USA. MFA in Architecture and Urban Planning. Works in spontaneous abstract painting and sculpture which represents feelings. The latest sculptures also question the boundaries of the function and non-function purpose of an object. Exhibiting since 1983 and works in some private and corporate collections.

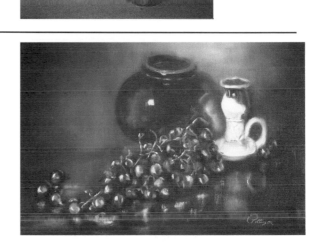

Destiny. Fiber glass, 20 x 38 x 39. Artist's collection.

Marguerite Petterson

PO Box 6508, Big Bear Lake, CA 92315
(714) 866-6408

A native Californian and graduate of San Bernadino Valley College, she has travelled extensively with her Marine husband gathering subject matter for her art throughout the 50 states. Working in oils in the traditional style, she is best known for her portraits, still lifes and western landscapes. Her work hangs in private collections across the US and England.

Study of Grapes. Oil, 12 x 16. Artist's collection.

Potenza

4601 Henry Hudson Pkwy, Bronx, NY 10471

Represented by Dalia Tawil Gallery, 112 East 7th St., New York, NY 10033

Has worked in New York for over twenty years as painter and sculptor. Is currently working on "The Peaceable Realm", a 360 foot painting dedicated to world peace to be exhibited world-wide. Future projects inlcude "Those United States" (paintings of each state) and a ten-acre sculpture garden in Sonoma County, California.

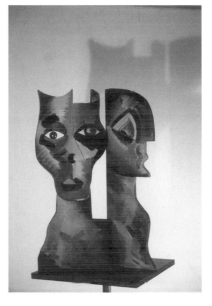

Expression #5. Wood and acrylic. Artist's collection.

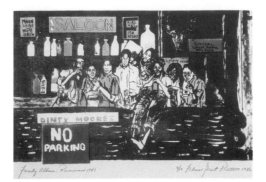

Felicia Grant Preston

21 E. 102nd Street, Chicago, IL 60628

Attended Southern Illinois University, The School of the Art Institute of Chicago, Northern Illinois University, the University of Ilinois, CC and Governor State University, BA in Art, Southern Illinois Univ.,1976. MSEd in Art Ed, Northern IL Univ. Active in several art groups. Exhibited in numerous invitational and juried shows. Specializes in drawing, abstract painting, and printmaking.

Family Album: Riverview 1947. Lithograph, 20 x 24. Artist's collection.

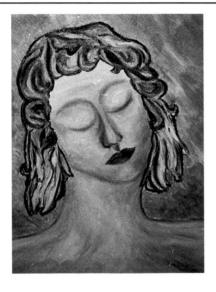

Nancy Procario

8825 Jane Way, Munster, IN 46321

I've painted and sculpted as a hobby since a child, being influenced by my Belgian mother's artwork. I'm a grad of Purdue University with a BA in communications/PR; however, recently making art my ambition. Three paintings were exhibited at NIAA and one at Lake Worth Art League. Presently working as an artist apprentice in Chicago and doing commissions.

The Stone Woman. Oil, 11 x 14.

Geraldine Provost

3665 - 24th Street, #1, San Francisco, CA 94110
(415) 648-3157

Since the first time I was given crayons and paper, I would spend hours drawing pictures as gifts or for fun. Family, friends and teachers encouraged me to continue my work and better my skills. Now that I live far away from many of these people, I still feel close to them when I draw or paint. I would hate to lose touch!!

Still Life - Fruit. Watercolor, 19 x 24. Artist's collection.

Melanie S. Rae

751 Page #4, San Francisco, CA 94117

Melanie was born in Columbus, Ohio and moved to Los Angeles. She received her first scholarhsip at Art Center College of Design. She finished a Fine Art degree in Oregon and certificate in graphic design. A scholarship and degree was given from the Academy of Art, San Francisco. Shows have been in Oregon and California and she loves science fiction art.

Fear In Dreams. Pastel, 19 x 23. Artist's collection.

Irwin Samuel Rappaport

260 Beach 137th Street, Belle Harbor, NY 11694
(718) 474-7300

Graduated with BFA from Visual Arts. Scholarship to National Academy of Fine Arts. Award from Waterford Crystal Co. Artwork displayed at the Queens Museum. Illustrations published in Parent Guide Magazine. Appeared on the Joe Franklin Show. Commissioned portrait for Egon Von Furstenberg. Promotional work for Diane Von Furstenberg.

Femme Fatale. Pencil, 20 x 30. Artist's collection.

M. Rendl-Marcus

Box 814, New Canaan, CT 06840 (203) 972-0643

I do oils and mixed media both medium sized and in fairly big size. All are semi-abstract. Most have either line or quasi-people-animal background. I have been in juried shows in Connecticut and Florida, including Faber Birren Color Award and Silvermine Northeast State Show. Also Stamford Illusion and Visual Illusions Show with Fantasy and Color.

Rise Above It. Oil, 24 x 32.

Sharon White Richardson

214 Old Oak Circle, Brandon, MS 39042
(601) 353-2787

Born in Woodville, MS. Received BS from University of Georgia, August 1969. Most influenced by Impressionists. Works mainly in oil and paste from life or on location. Works accepted to national and international juried shows including Salmagundi. Teaches private classes in oil and pastel with emphasis on color. Partner in Workshops Unlimited.

Reflections. Oil, 24 x 30. Artist's collection.

Robie

PO Box 13093, Miami, FL 33101

Cuban-American artist was born in Havana, Cuba on February 16, 1953. Robie spent his youth in New York where his inclinations for music immersed him in the creation world of the sixties in Madrid, Spain where he initiated his studies in science. Back in Miami in 1979 he enrolled in the Arts. Robie's metapsycho-cosmic art approach to painting covered by international press.

Unknown Universe . Spray paint, 28 x 22.

Howard Robson

3807 E. 64th Place, Tulsa, OK 74136 (918) 492-3079

Pictureworks, PO Box 2437, Broken Arrow, OK 74013 (918) 251-1624

Howard Robson retired from the business world at 59 in 1978. He started serious photography in 1983 and is self-taught. He works in B/W and color, 35 mm to 4 x 5 field and view cameras. He is at ease in commercial/industrial as well as with pictorial, nature, abstract or photo-journalism. Has won many contests, sold many book and magazine covers and editorial shots.
The Sweeper, Xian, China 1985. Photography, 8 x 10. Artist's collection.

Ernesto A. Rodriguez

55 Overlook Terrace Apt 4H, New York, NY 10033

Represented by Pine Tree Gallery, 114 Pine Street, Troy, AL 36081

Exhibited in the United States, Europe and South America. Originals are owned privately. My work and experience has been documented in publications and newspapers.

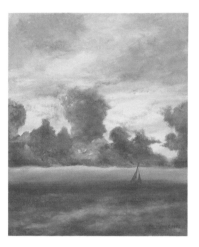

Sail. Oil/ acrylic, 20 x 16. Artist's collection.

Carol Rosen

Beavers Rd., RR 3 Box 57, Califon, NJ 07830
(201) 832-5564

Represented by 14 Sculptors Gallery, 164 Mercer St., NY NY 10012 (212) 966-5790

Collections: Smithsonian Institution, New Jersey State Museum, Kirke-Van Orsdel. Exhibits: 14 Sculptors Gallery, NYC; Alternative Museum, NYC; Getler/Pall Gallery, NYC; Brooklyn Museum, NY; Alberta College of Art, Canada; Downey Museum of Art, CA; California Palace of Legion of Honor; Newark Museum, NJ; Ohio University.

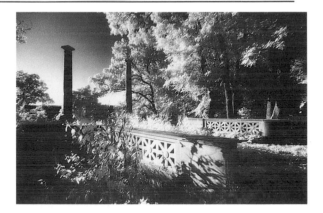

Intuitions and Boundaries I III. Paper, Wood, 29 x 43 1/2 x 14. Artist's collection.

Jonathan Rosen

Box 630216, Riverdale, NY 10463

Jonathan Rosen has been working in mediums of light for the past 20 years. Studied with David Vestal, Willard Van Dyke. His book <u>Streets</u> 1981, Guignol Press now available through the Artists Reviews, Popular Photography and Photograph Collector. In the past 2 years he has participated in over 30 shows. Next one man show at the Nicholas Roerich Museum, December 1987.

Columns. Silver Gelatin Print, 16 x 20. Private collection.

R. Kay Rudisell, OPAA

Route 6, Box 53-B, Hamilton, AL 35570
(205) 921-2907

Represented by Pine Tree Gallery, 114 Pine Street,
Troy, AL 36081 (205) 566-6578
Self-taught pastellist with special interest in
impressionistic painting and portraits. Art
memberships included a titled membership in Oil
Pastel Association of New York, with charter
memberships in the Pastel Society of the West
Coast in California, the Degas Pastel Society of
New Orleans, and the National Museum of
Women in the Arts, in Washington, DC.
Reflections from a Street-Light. Soft pastel, 18 1/2 x 21. Artist's
collection.

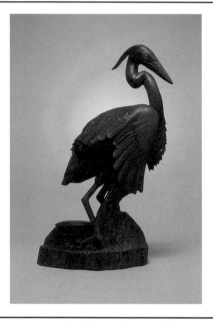

Richard Leon Rulli

Rd #1, Box 171A, Thunderhill Rd, Woodbourne,
NY 12788

A dedicated naturalist and consistent winner of
top honors for his hardwood sculptures. His
current project is a twelve foot American Eagle,
of a single, four ton piece of American black
walnut.

Great Blue Heron. Black walnut, 48 x 30. Artist's collection.

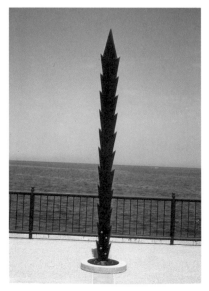

Jeffrey J. Rutledge

130 Squirrel Road, Dayton, OH 45405
(513) 223-1472

Represented by Gilman Gruen Gallery, 226 West
Superior St., Chicago, IL 60610 (312) 943-3841

I am seeking professional representation for my
sculptures. My sculptures accent government
lobbies, corporate offices, parks and
residences. These dynamic energy totems
excite any environment. They compliment our
contemporary age of technology and
investigation. My style is distinctive.
The Flame of Inspiration. Wood/steel, 12 x 14 x 3. Artist's
collection.

Ken Scallon

41 First Ave. Apt 1, New York, NY 10003
(212) 533-0925

Represented by Elizabeth Sylvester, 1922
Goldback Ave., Ronkonkoma, NY 11779

I have been creating this type of art work using
pen and ink and colored pencils since 1981. The
most interesting result is the reaction my art
produces in people. It seems many people look
at art and want a complete explanation of what's
happening in the piece. I'm glad my art keeps
them wondering.

Now I See It. Pen, ink and colored pencils, 14 x 16. Artist's
collection.

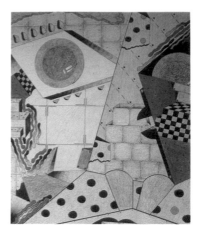

Ron Scarselli

1624 Landa Street, Los Angeles, CA 90026

An image should be the result of and should result
in an emotional exchange between the artist and
the image and the image and the viewer. It is not
enough for me if the image is merely decorative.

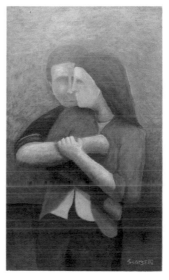

Running Late. Oil on masonite, 18 x 30. Artist's collection.

Ginny Seibert

PO Box 521442, Longwood, Fl 32752-1442

Represented by Jim Seibert, 4403 Vineland Road,
Suite B17, Orlando, FL 32811 (305) 849-9912

In 1982, I began art classes at Miami Dade
Community College to develop my God-given
talent. Towards the end of 1985 began pursuing
art as a career. Wildlife is the subject of my
artwork which I photograph before sketching.
I've experimented with a variety of medias, but
prefer pencil to produce wildlife artwork in either
color or black and white.

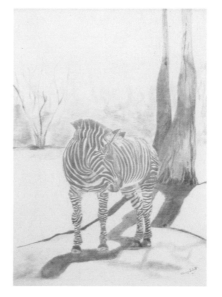

Pencil, 18 x 24.

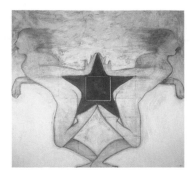

Jesus Selgas

353 W. 44th St. 5-B, New York, NY 10036

Represented by Aleman's Galleries, 30 Newbury St., 4th floor, Boston, MA 02116

Born 12/24/51 in Cienfuegos, Cuba. American resident since 1980. He has been exhibiting his art for around ten years. Winner of first prize for artistic tapestries, National Museum of Decorative Arts, Havana, Cuba, 1977. He recently had a group show at the Phillip Stanbury Gallery in New York and one of his original artworks is in Artwork Magazine June-July, New York 1987.

Escape. Oil, 68 x 74. Artist's collection.

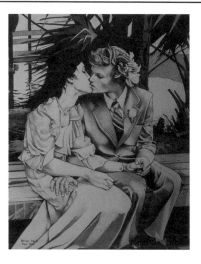

Brian J. Sells

6093 NW 9th Ct., #2, Margate, Fl 33063
(305) 979-7927

Best of Show 1979 Beaux Arts Promenade; 1986 1st Place winner Woodstock Art Festival. No formal training. Currently working as a billboard painter while accumulating his art for one man show. Works only in charcoal, colored and black and white.

Kiss. Charcoal, 30 x 22. Artist's collection.

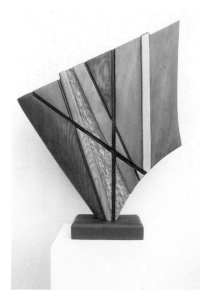

Carol Setterlund

215 Commercial, Cloverdale, CA 95425

Work is included in public and private collections across the US and abroad. Collections include Impel, Long Island; Trimensions, NYC; Saks Fifth Avenue, Beverly Hills; Cello Con. Sunnyvale, California. " Shield for Travelers, Merchants, and Thieves" is part of a current series of angular shield-like forms , a departure from the disk s and spheres of the past few years.

Shield for Travelers, Merchants, and Thieves. Wood sculpture, 35 1/2 x 28 1/2 x 7 1/2. Artist's collection.

Mikhail Shabshay

8200 21st Avenue, Brooklyn, NY 11214

I was born in the USSR. In 1960 I enrolled in the School of Arts. My paintings were exhibited on Madison Avenue in 1985, and in 1986 in Soho. This particular painting was exhibited on Madison Avenue.

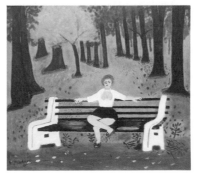

Lady on the Bench. Oil, 34 x 31. Artist's collection.

Alex Shagin

1319 Havenhurst Dr., #1, Los Angeles, CA 90046
(213) 656-2978

From Leningrad, Alex has lived and worked in Los Angeles since 1979. Internationally acclaimed medallic and graphic artist, winner of many prestigious awards and commissions, has created over 100 art medals and commemorative coins for many significant events in fine arts and Olympic sports. Also works in bas-relief and small scale bronze and silver sculpture.

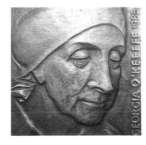

Georgia O'Keefe, Commemorative Medallion. Cast Bronze, 2 1/2 x 2 1/2.

Susan Hillary Shapiro

60 East 12th Street, NY, NY 10003 (212) 460-9688
(213) 451-0774

Since 1982 I've been painting on transparent surfaces; glass and acetate. Backlighting causes different layers of the colorful pieces to be illuminated, much like stained glass. My new works are mainly on acetate which can be rolled up and down and used as windowshapes. Currently Kensu Ltd. is using my painting as prototypes for silk and cotton scarves.

Faces. Acrylic on glass, 40 x 40. Artist's collection.

Jean Sheldon

PO Box 27, Okauchee, WI 53069

Many of my current pieces are based on a collection of illustrated poems. The verse accompanying this piece is:

You and I are a lot alike -
both of us wanting to dance through life,
neither of us wanting to lead.

Neither of Us Wanting To Lead. Oil/Masonite, 30 x 40. Private collection.

Ignatius T. Shen

5420 N. Sheridan Avenue, #408, Chicago, IL 60640

Began painting 1944 Shanghai, China. Education: Shanghai University, Washington University. Awards: Chinese National Watercolor Award, etc. Exhibition: St. Louis Artists Coalition, St Louis; Chinese National Artists Exhibition Peking China; Shanghai Artists exhibition, Shanghai, China. Members of Chicago Artists Coalition and American National Artists Society.

Eagle. Watercolor, 14 x 24.

Shan-Shan Sheng

Apley Court #44, 16 Holyoke St., Cambridge, MA 02138

A native of China. Shan-Shan currently is an artist in residence at Harvard University. She earned her MFA from Univ. of Mass, Amherst. Shan-Shan held five one-person shows in Boston and NYC in past two years. Her works have been included in the permanent collection of Chinese Modern Painting by Harvard University. She recently completed a Public Art Commission for the Tower Library, at University of Mass, Amherst.

Cows. Oil on paper, 40 x 28. Artist's collection.

Hilda Jaye Sheridan

7140 E. Sunnyvale Rd, Paradise Valley, AZ 85253
(602) 998-0317

J's Gallery, 2021 E Camelback Rd, Phoenix, AZ
85016 (602) 468-1828

Born in Connecticut. Art Career School, NYC. Art
Major, AZ State U, all media. Numerous jury
shows, awards: Silver Spring, MD; El Paso, Tx;
Scottsdale, Arizona; Palma de Mallorca, Sp.
(where she recently lived 8 years involved in local
art shows). Live in Paris 7 years, London, Japan,
many European street scenes. Presently
maintains studio and gallery in Scottsdale.

Spanish Tienda Artesiana. Oil, 13 x 7. Artist's collection.

Robert E Sholties

1000 Frank Ave., Jeannette, PA 15644

Born in Greensburg, PA, Robert Sholties received
a bachelors degree from Penn State University
and has lived in various parts of Pennsylvania
throughout his life. Examples of his unique dream
visions have been included in national juried
exhibits in New York and California.

Out of Control. Acrylic, 40 x 62. Artist's collection.

Gerald Siciliano

261 Fourth Avenue, Brooklyn, NY 11215
(718) 636-4561

Represented by Jayne H. Baum, 109 Hudson St.,
New York, NY 10013 (212) 219-9854

Education: BFA, Masters Degree, Pratt Insitute,
NY; Marble Carving, Istituto D'Arte, Pietra Santa,
Italy. Exhibitions: The Brooklyn Museum, Jayne
Baum/Stephen Rosenberg/ Iolas Gallorios,NY;
Pratt Institute; Rochester Inst, NY. Collections:
The Brooklyn Museum. Prviate collections: USA,
Italy, Germany, Switzerland. Awards: Pratt
Fellowship, Caps Sculpture Grant.

Frankl (Il Partigano). Marble, 33 x 28 x 24. Private collection.

Erick J. Simons

1699 Laguna Street, #102, Concord, CA 94520
(415) 825-4125
Represented by Image Marketing International,
18300 Von Karman, Suite 700, Irvine, CA 92715
(714) 660-9010
Graduated Northern Michigan University 1982 BFA.
1983 relocated to San Francisco Bay area. 1986
Encyclopedia of Living Artists. 1986 signed with
Light Writing Production , NY and LA Picture
Agency. 1987 transferred contract Image
Marketing Intl. for World Distribution. 1987 entrant
Life Magazine contest for Young Photographers.
Special thanks to J. Barberio of Image Marketing.

Trappers Cabin - Dead River Backwaters. Photograph.

Wally A. Smith

3004 Oakbridge Dr., San Jose, CA 95121
(408) 238-2169

Attended De Anza College Interm Artist
Association. Developed theme paintings 80's.
Many sidewalk and cafe shows in Berkeley and
Santa Cruz, California.

Bowtie. Oil,/acrylic, 24 x 30. Artist's collection.

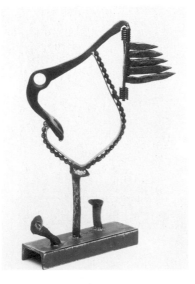

Stan Smokler

873 Broadway, New York, NY 10003

Represented by Ledis-Flam Gallery, 108 N. 6th
Street, Brooklyn, NY 11211

Born in New York City. Work primarily steel
abstract assemblages. Currently involved with
public and private commissions as well as
group and one person exhibitions for 1987/1988.

Bountiful Spirit. Steel, 20 x 12. Artist's collection.

Waldemar Smolarek

807 1424 Nelson St., Vancouver, BC V6G 1L8
(604) 685-8781

Represented by Virginia Miller Gallery, 169
Madeira, Coral Gales, FL 33134 (305) 444-4493

Education: Warsaw School of Art 52-55, Warsaw
Academy of Fine Arts 55-57. Permanent
collections: Artist cooperative, San Francisco.
Selected Artist Gallery, NY; Kunstlerhaus, Vienna;
Museum of Modern Art, Miami; Kitakyushu City
Museum of Art, Japan; Galerie Classiqua
Stockholm; Gallery Silvia Menzel, Berlin.

Turbulence. Oil, 35 x 28. Artist's collection.

Susana Sori

174 NE 24th St., PO Box 4394, Miami, FL 33101
(305) 576-7350

In 1979 to 1983 spontaneous symbols manifested
in drawings. Its arrangements triggered in me
insights to the play of universal forces. Now these
forms in clay, wood and metal are projected as
indoor or outdoor sculptures to exist surrounded
by sub-atomic forms which they represent and
make up all that lives in the universe...the dancing
vibration of life unending.

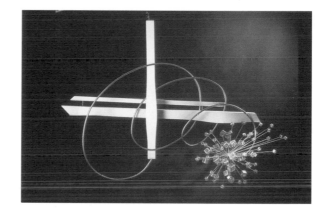

Stream of Being. Mixed-media sculpture, 72 x 57 x 24. Artist's
collection.

Christopher Sorrenti

112 Lockwood Lane, Pleasant Hill, CA 94523

Represented by Stephen Nicklaw, 1033 Pleasant
Valley Drive, Pleasant Hill, CA 94523 (415) 932-4791

Forever a versatile artist who lives to create; my
medium is airbrush whose specialties are
technical and stylized graphics for clients, i.e.
Jayregui, Stien and Associates; Disney Studios;
Elam Magazine; Marine World Africa USA and
Andy's T-Shirts. Christopher is a member of
Northern California Special Effects Network and
Artist in Print. We create from the heart.

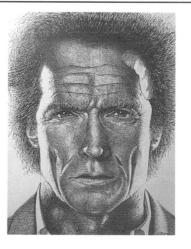

President Eastwood. Pen and Ink, 8 1/2 x 10 1/2. Artist's
collection.

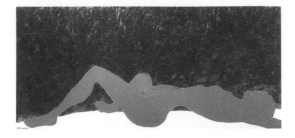

Sara Sosnowy

423 Wythe Ave, Brooklyn, NY 11211

Born and raised in Houston, Texas. Received BFA from Stephen F. Austin State University, Nacogdoches, Texas. Currently working for a New York City gallery.

The Lover. Oil, 64 x 30. Artist's collection.

Manuel Soto-Munoz

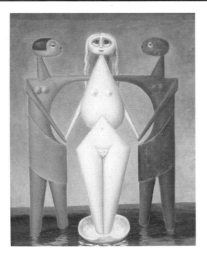

1605 Indo St., El Cerezal, Rio Piedras, Puerto Rico 00926

To me, art is life. I paint in the tradition of the Renaissance with the classical art form in mind in both my realistic and modern paintings. The picture plane is an area of reference from which all forms grow forward. This plane must be preserved at all costs as here lies the foundation of substance and weight, said Miller, my teacher, Art Students League, NY.

The Birth of Venus. Oil, 24 x 30. Artist's collection.

Pryor Speranza

4 Debra Lane, Basking Ridge, NJ 07920

I see my internal self as a pool of water at the bottom of a deep well. I go to the well with different questions, seeking answers to satiate my thirst. The self is a pool of many different types of resources: the intellectual,intuitive and emotional senses and memories are stored there, coupled with the energy and the will to stir them up.

In Response to An Essay: The Well. Clay, 96 x 25 x 16. Private collection.

Joseph Stearns

24302 45th Ave. West, Mountlake Terrace, WA
98043 (206) 774-6679

Bachelor of Fine Arts, Kendall School of Design,
Grand Rapids, Michigan 1983. Exhibited in Society
of Illustrators Gallery, New York City, 1983. Exhibited
in the Phinney Center Gallery, Seattle, Wash. 1986.

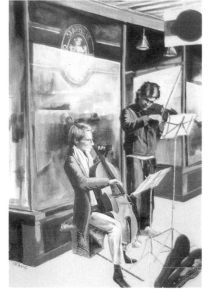

City Series. Oil, 16 1/2 x 23 1/2. Artist's collection.

Sarah Sturgis

822 Leland #3 South, St. Louis, MO 63130

Represented by Elliot Smith Gallery, 360 N. Skinker
Avenue, St. Louis, MO 63130

Originally an engineer. BS Physics, BGS Space
Science, '79. Emerging artist developing rapidly.
Currently expanding to other Midwestern cities.
Included in major national competitions and
invitationals. Works in private and corporate
collections. Sculpts primarily in stone and stone/
mixed media. Also does bronze and other
media. Has done large commissions.

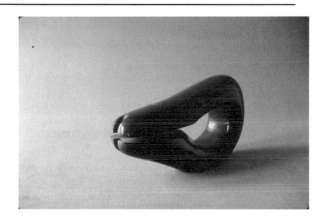

Enoch's Dream. Stone, 9 x 15 x 5.

Helen Swan

270 Market Street, Folsom, CA 95630

Represented by Leah Niemoth Gallery, 306
Decatur Street, Folsom, CA 95630

Born in Arkansas. Studied Fine Art in Northern
California while raising a family. Work shown in
local, national and international juried shows. She
works in oil, pastel or watercolor, striving to
involve the viewer in the mood of the painting.
Signature membership - Oil Pastel Association of
New York. Active member Sacramento Fine Arts
Center.

Summertime. Oil Pastel, 20 x 24. Artist's collection.

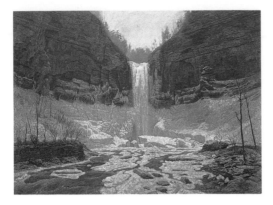

Muli Tang

20-3B 700 Warren Rd, Ithaca, NY 14850
(607) 257-0341

MA Central Academy of Fine Art, Beijing. MA Royal College of Art, London. Artist-in-Residence at Cornell University, US. 1983 Peter Moorse Foundation Award, UK. Works exhibited and collected by many galleries, institutions and collectors in America, Europe and Asia. Specialized in waterfalls, park scenery, portraiture, nudes and animals in oil, watercolor and charcoal.

Taughannock Fall in Winter. Oil, 41 x 55. Private collection.

Stephanie Taylor

1561 Elsdon Circle, Carmichael, CA 95608
(916) 488-1907

Taylor has created site-specific commissions for the corporate market since 1977 from Hawaii to NY. The pieces are often large, on canvas, paper and walls, and emphasize unique and dynamic solutions. Also designs a line of tapestries. Clients include Xerox, Sheraton, Texaco, AMFAC, FIB, LA City. Currently, Hollywood Roosevelt Hotel restoration. Also exhibits.

Old Tavern. Acrylic and pastel, 16 x 16. Private collection.

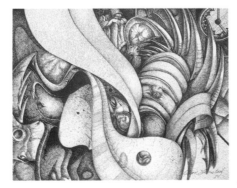

Nixon Thorstad

4362 Second St., Pleasanton, CA 94566

My hope is that my images, whether sculpture, painting or drawing, will be present in the minds of the people who view them, something that they can reflect back on. It may not change their life but for a brief moment it will make their time different.

A Time When Necks Were Painful. Ink on paper, 11 x 14. Artist's collection.

Brian Tolbert

1519-B Camden Court, Wankesha, WI 53186
(414) 549-0911

Brian has worked in many areas but he chooses
to work to with contemporary themes in most
instances. His favorite subjects are people and
places. Brian chooses to work on odd surfaces
due to their being more challenging, and once
even turned a 240Z into a mobile art show,
covering the car in an early 80's motif.
"Compelled to show life as it is".

Cafe' Voltaire...., Marker, 14 x 22. Private collection.

W. Douglas Topper

146 Fifth Avenue, Apt 7A, New York, NY 10011
(212) 924-0031

W. Douglas Topper, a native of Pennsylvania,
relocated to New York to study at the Tish School
of Arts where he received a BFA in theatre design
and illustration. Further training at the Fashion
Institute of Technology led to a style of
fragmented realism rendered in pencil and
watercolor. Published work for clients include
Macy's, 1200, and the Village Voice.

P&SXO. Pencil, 18 x 24. Artist's collection.

Annabel de la Torre-Bueno

15111 Otsego St., Sherman Oaks, CA 91403

Art is great when it communicates an idea that
gives new understanding. No degree of skill or
technique can make a painting great if what it
communicates is mediocre. A portrait is great
when it shows the subject's inner strength and
beauty. A landscape is great when it fills the
viewer with joy and zest for living as nature in its
glory can do.

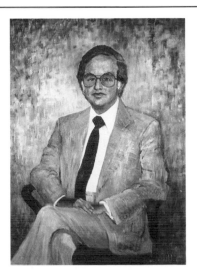

Kenneth H. Klee - Portrait. Oil, 34 x 48. Private collection.

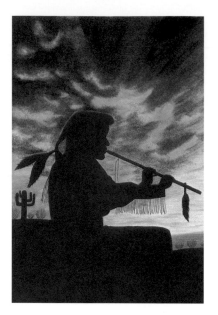

Nelda Trabow

9637 Alta Loma Drive, Alta Loma, CA 91701
(714) 989-1248

Nelda Trabow, born in Glendale, California in 1944. She is a self taught artists who has always had a great love for western art. With her Cherokee Indian ancestry, she is partial to all types of Indian subjects. She has sketched most of her life and painted for the last 13 years. Her work has been shown in major shows such as Art Expo-Cal and ABC Show LA.

Peaceful Moment. Soft Pastel, 14 x 18. Limited Edition.

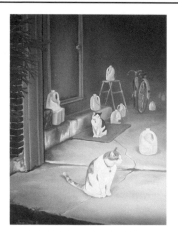

Barbara Gene Tummolo

12 Greenridge Way, Spring Valley, NY 10977

Represented by Ariel Gallery, 76 Greene St., Soho, NY 10012

Presently taking commissions for photo-realistic animal portraits, formal and informal. Also portraits of people, homes and all other commissions. Write for free price list. Orders taken by mail, nationally painted from photos supplied by client. Works seen in national magazines and many private collections. Wall mural commissions taken locally only.

Cats With Milk Jugs. Oil, 24 x 18. Artist's collection.

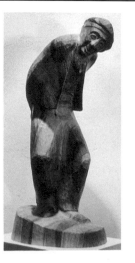

Don Turano

2810 27th Street, NW, Washington, DC 20008

Represented by Kathryn Murray (202) 462-3718

Commissions: Washington National Cathedral, DC; National Portrait Gallery, Dumbarton Oaks DC; World Trade Center, AFL-CIO, Univ of Notre Dame, Temple Micah, Maximum Savings Bank - 2 branches etc. Exhibits: PA Academy of Fine Arts, Phila.; St. Louis Museum, Mo.; Corcoran Gallery of Art, DC; University of Colorado; Audubon Annual, etc. In many private collections.

Dancer. Poplar, 26 x 10 x 13. Artist's collection.

Bonese Collins Turner

4808 Larkwood Ave., Woodland Hills, CA 91364

Represented by Orlando Gallery, 14553 Ventura Blvd, Sherman Oaks, CA 91403

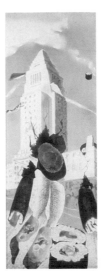

Cal St U, MA. U of Idaho, M. Ed. Professional artist and educator teaches at Cal St U, Northridge & LA Pierce College. Recent solo shows: U of Nevada, Reno Aug 87. Orlando Gallery Oct 86. Many national exhibitions. Collections: Smithsonian Permanent Collection, White House, Wash., DC; Home Savings & Loan, Nebraska; Public Libraries. Awards: National Watercolor Society, San Diego WCS.

Who Says You Can't Fight City Hall? Watercolor, 63 x 24. Artist's collection.

Jose Meza Velasquez

532 16th St. #605, Oakland, CA 94612 (415) 835-1945

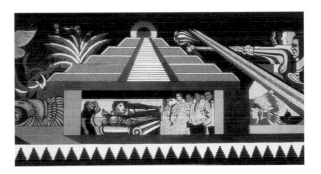

Born in Nayarit, Mexico. Muralist. Exhibitions: Galleries and Museums in the US, Mexico, Central America, Dominican Republic, and Africa. Murals: US & Mexico. Awards: 1st place - National mural Painting - Mexico; 1st place - National poster - Mexico; Best mural in the Peninsula - US. Art Positions: Professor - Painting and Drawing, Universidad Autonoma de Mayarit, Mexico. Expressionist.

Mural of La Raza. (detail section). Acrylic, 15.5 ' x 86.8'. Public Youth Center.

Beth Watson

718 Broadway, Apt 4A, New York, NY 10003

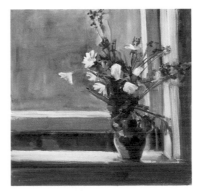

Graduate of Oberlin College. Spent 25 years in suburban NE as wife/mom. In 1982 renewed art studies: Silvermine in Ct., Boston Museum School, Art Students League and Sculpture Center in NYC. Now living in NYC, go to France frequently to paint landscape.

New York Flowers. Oil, 20 x 20. Artist's collection.

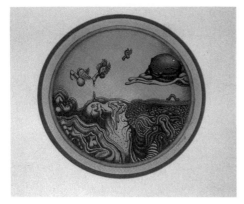

Marsha Miller Wayne

PO Box 9712, Tulsa, OK 74157

I am presently working in the graphic arts. I have done commissioned pieces in pencil, ink, paint, silkscreen and etched glass. I have done wildlife, landscapes and portraits. My personal work is erotic. I am self trained in the media I work in. Expressing feeling and form through texture is what I strive for.

Migrations. Mixed, 9 x 9. Private collection.

Myron Weber

300 Central Park Avenue, Hartsdale, NY 10530

BFA Ohio State . My work consists of drawing, collage, and the combination of the two, using primarily markers and various collage materials. Oriental Zen calligraphy with its strength, power and delicate simplicity has influenced my work. My art exhibits an open air approach to defining my subjects as directly as possible. Extensive exhibitions in metropolitan New York.

Self Portrait with Manhattan Nose. Collage, 14 x 17.

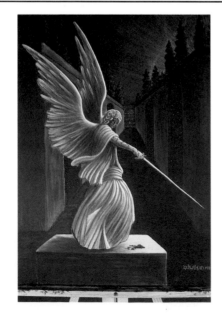

Leilah Wendell

8 Bernstein Blvd, Center Moriches, NY 11934

Select works handled by Leon Boyar Associates, Box 1151 Wall Street Station, NY, NY

American Artists Professional League member, Leilah is a new age romanticist, whose art, transformed by the mystical, has been exhibited most recently in Morin-Miller Galleries, NYC; Islip Art Museum, NY; Taub Gallery, PA; International Center of Contemporary Art, Paris, France; and over 50 other group and individual showings. She is currently represented by Ariel Gallery, NYC.

The Sentinel. Acrylics, 24 x 30. Artist's collection.

Daniel M. Wenk

8205 S. Newland, Burbank, IL 60450 (312) 430-4814

Daniel M. Wenk is a graduate of Northern Illinois University with a BFA in Illustration. Although skilled in many forms of media, Mr. Wenk prefers working mostly in water colors. He is currently freelancing out of his home near Chicago, Illinois.

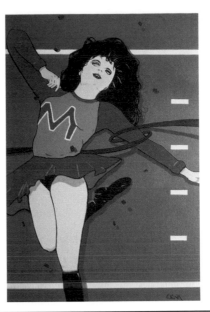

Rah Rah. Acrylic. 16 x 20.

Yvonne D.Wesser

12 East 86 Street, Apt 1631, New York, NY 10028

Represented by Greene Art Gallery, 29 Whitfield St., Guildford, CT 06437

Born London, England. Studied Art Students League, NYC - Hale Groth Stamos. 7 awards. 10 solo shows. 17 group exhibitions in 1986. Some Jurors were: MOMA, SF, CA, Metropolitan Museum of Art, NYC, MOMA, NYC, Brooklyn Museum of Art, NYC; Yale School of Art, Los Angeles Museum of Art . National and world tours planned 1988/89.

Post No Bills #7 - Stols. Oil, 56 x 36. Artist's collection.

Laura Williams

1847B Stockton Street, San Francisco, CA 94133

Laura is a freelance illustrator whose fine art background is reflected in a disarming ability to infuse her works with personality. Her emphasis on color is most exciting and almost eccentric, yet always contained within context. There is a freshness in approach to the medium which carries charm with conviction.

Job Safety. Acrylic, 6 x 12. Artist's collection.

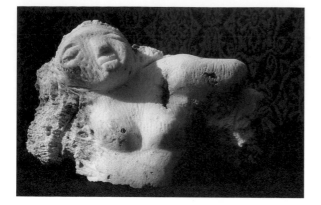

david willis

PO Box 768, FPO Seattle, WA 98773
(098) 932-1840

Represented by Iris DeMauro, Archetype 411 East
Ninth St., NY, NY 10009 (212) 529-5880

david willis began sculpting in 1965 and has
exhibited in galleries in Italy, Germany, England
and Japan and the United States. The New Britain
Museum of American Art acquired one of his
works in 1979 and his statues are in private
collections throughout the world. He has lived in
Japan for the past six years and has sculpted
exclusively in Pacific Coral. *Floating in the Sea.*
Coral sculpture, 12 x 18. Artist's collection.

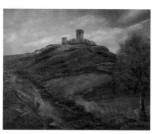

Lynne Reynolds Worsham

PO Box 21225, Oklahoma City, OK 73156
(405) 843-4129

Represented by 10 Talents Gallery, 2661
Sheridan Road, Zion, IL 60091 (312) 872-8330

Paintings won national competitions in
Washington DC; Lake Worth, Florida; Edmond,
Oklahoma. Juried shows in Oklahoma City.
Member of American Society of Artists,
Oklahoma Artists Association, Oklahoma Art
Guild, Edmond Art Association, Southwest
Oklahoma City Art Association and
Independent Oklahoma Artists.

Castle of the Kings. Oil, 24 x 30. Artist's collection.

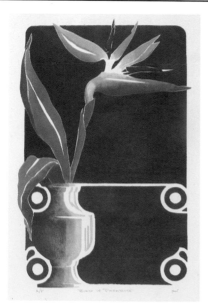

Patricia A. Wright

1892 Tahiti Drive, Costa Mesa, CA 92626
(714) 556-0713

Represented by Cove Gallery, 1492 S. Coast
Highway, Laguna Beach, CA 91651
(714) 494-1878

A printmaker since 1980, Pat studied under the
last S. Cal. Master printer, Gerry Frye. She is
currently working on representational native
American art in etchings and collagraphs. Pat is
represented by these galleries:
 Cove Gallery, Laguna Beach, CA
 CMAL Gallery, Santa Ana, CA.
Bird of Paradise. Collagraph, 24 x 30. Limited Edition of 40.

Dana Wylder

West 111 39th Avenue, Spokane, WA 99203

Island Art Gallery, Frenchman's Reef Hotel, Saint Thomas, Virgin Islands 00801

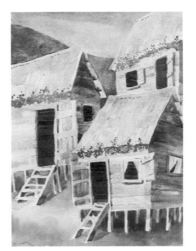

In Dana Wylder's recent works you feel the sultry twilights and the glaring noon heat of the Caribbean, where she is now sailing and painting the sea, the lands and the people at their work and play. An award winning professional artist, an illustrator and instructor, Dana Wylder has shown in international exhibitions and solo shows in the US and abroad.

Old Lace #2 Grenada's North Coast. Watercolor, 19 x 13. Private collection.

Laurie Parsons Yarnes

448 Woodcock Road, Sequim, WA 98382

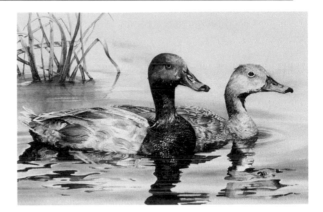

Laurie was raised on a large farm which lies alongside the state wildlife refuge in Spirit Lake, Iowa. She strives to reach her goal to aid in conservation efforts through her art. Her entries placed in the top 10 in Ala./ State Duck Stamp Competition 1985-86. 1st in Washington State and third in National for American Mothers Inc. Arts.

Just Up. Watercolor, 13 x 18. Artist's collection.

Katarina Sabinska Zavarska

1134 East 72 St., Brooklyn, NY 11234 (718) 251-3690

Represented by Robert A. Frauenglas, 1134 E 72 St., Brooklyn, NY 11234 (718) 251-3690

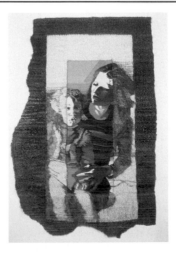

K. Zavarska was born in Bratislava, Czechoslovakia. Trained in the long tradition of innovative Slovakian tapestry, she is one of the finest tapestry artists in Central Europe. Her tapestries hang in the permanent collection of the Slovak National Gallery and have appeared in over 25 exhibitions since 1975. She works with wool, cotton, sisal and other fibers.

From the Album. Tapestry, 45 x 71. Artist's collection.

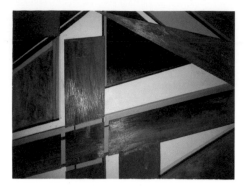

J. W. Zillion

3739 B Madison Lane, Falls Church, VA 22041

Zillion began work in a packing plant and organized it, later becoming a union representative. He has travelled extensively, and uses this as a back drop for his self-taught expressionist work. His diverse experience in the US, Europe, Africa, Asia and the Middle East has inspired his work and range of color and motion. Religious frameworks have established his style.

New York, New York. Acrylic-oil, 30 x 40.